IMAGES
of America

CHICAGO IN THE GREAT DEPRESSION

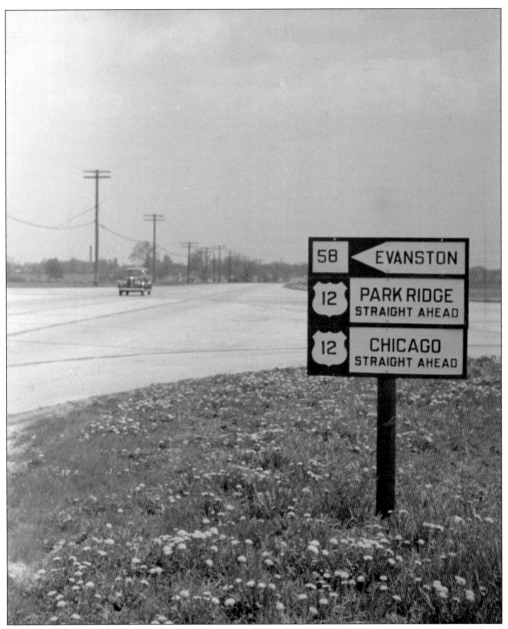

"All roads lead to Chicago," boasted the city's chamber of commerce in 1935. Eleven federal highways converged there with more than 250,000 cars moving through the city limits every 24 hours. Motorbus transportation developed into a system with 13 bus lines operating out of the city in every direction to towns across the country. One leading bus line could employ more than 12,000 people. (Photograph by Arthur Rothstein, courtesy of the Library of Congress.)

ON THE COVER: John Vachon captured a variety of people who had just stepped down the stairs from the "L" platform to arrive in the Chicago Loop. Dressed very well, as was the custom when going "downtown," they awaited the arrival of the streetcar to take them to their destinations. (Courtesy of the Library of Congress.)

IMAGES
of America

CHICAGO IN THE
GREAT DEPRESSION

James R. Schonauer and
Kathleen G. Schonauer

ARCADIA
PUBLISHING

Published by Arcadia Publishing
Charleston, South Carolina

Printed in the United States of America

Library of Congress Control Number: 2014954062

For all general information, please contact Arcadia Publishing:
Telephone 843-853-2070
Fax 843-853-0044
E-mail sales@arcadiapublishing.com
For customer service and orders:
Toll-Free 1-888-313-2665

Visit us on the Internet at www.arcadiapublishing.com

To those who documented the Great Depression in Chicago

CONTENTS

ACKNOWLEDGMENTS

It is with great respect that we acknowledge all those who have helped and supported us in the creation of this book. We express our gratitude to our editor, Jesse Darland, who patiently guided us along the way. We thank Regina Ziemann, John Rehling, George and Judi Kazda, Stanley Shier, Marilyn Gliva, Tom Schonauer, Virginia Gliva, and Bess Schonauer for allowing us to use their personal family photographs and for their time and effort in providing primary source histories of their families. We deeply appreciate the use of John Chuckman's extensive collections of the visual history of Chicago. The Chicago Public Library, especially Cynthia Fife-Townsel, patiently assisted us and we are thankful. It would have been impossible to complete this project without the Library of Congress, the Federal Bureau of Investigations, and the US Department of Justice. We are deeply indebted to the photographers of the Farm Security Administration, which include the following: Dorothea Lange, John Vachon, Arthur Rothstein, Russell Lee, Edwin Rosskam, and Jack Delano, who documented the city with rich photography. Thank you Pat Kelly for your wonderful boat tours of Chicago, and Douglas Deuchler, whose own books gave us the idea to write this one. Thank you Joe Tumino and Lisa Maurizi for your musical expertise and reference materials. We feel honored to thank the memory of Carl Sandburg for his wonderful poem "Chicago."

A special thank you goes to our daughters, Erin and Jamie Schonauer, for their continual love, encouragement, and inspiration.

Unless otherwise noted, images are part of the authors' collection. Other images appear from the following sources: Library of Congress (LC), Prints and Photographs Division (P&P DIV); Historical American Buildings (HABS); US Government, Department of Homeland Security, Coast Guard (PD-USGOV-DHS-CG); *New York World-Telegram & Sun Newspaper* Collection (NYWT&S); US Department of Justice (USDOJ); Federal Bureau of Investigation (FBI); National Archives and Records Administration (NA&RA); Creative Commons (CC by SA); Franklin Delano Roosevelt Presidential Library and Museum (FDR); Illinois Department of Transportation (IDOT); and US National Archives HMS Record (USNA/HMS).

INTRODUCTION

In 1929, Pres. Herbert Hoover avowed, "Any lack of confidence in the economic future of the basic strength of business in the United States is foolish," in his response to the Stock Market Crash on Black Tuesday, October 29. In a few years, Chicago had about 600,000 unemployed citizens. The homeless were creating "Hoovervilles" in empty lots and parks or were sleeping under Wacker Drive, blaming Hoover for their plight. The good times of the Roaring Twenties were over. Or were they?

Chicago was already in the midst of gang warfare between mob bosses who where raking in money by selling illegal liquor, gambling, thievery, and prostitution. On February 14, 1929, the Saint Valentine's Day Massacre brought down the gang of George "Bugs" Moran, the North Side boss, whose top men were murdered. Everyone suspected Al Capone, but there was no evidence to connect him to the shootings. This time of terrible violence was alleviated with the imprisonment of Capone, the South Side boss, who, in 1931 was convicted of tax evasion and sentenced to 11 years in a federal penitentiary. Later, the death of John Dillinger, who was gunned down in Chicago in 1934, seemed to end the infamous gangster era. But it was the repeal of Prohibition in 1933 that highly inhibited the mob, also known as the Outfit, because much of their revenue came from selling illegal booze. The ordinary citizens were happy to enjoy this indulgence legally once more.

In 1933, Franklin Delano Roosevelt took office on the promise of a New Deal, rallying Americans with better expectations. During his campaign, he said, "I pledge you, I pledge myself, to a New Deal for the American People." Chicago responded with new prospects of her own. The Century of Progress International Exposition of 1933 was created without taxpayer money. Instead, money was collected through bonds, shares, and contributions. The exposition was such a success in creating revenue and jobs, that President Roosevelt encouraged Chicago to continue it another year, into 1934. Looking toward the future in both science and culture, the exposition was meant to promote, to those who experienced it, a positive perspective; there was a light in the darkness of present circumstance.

In 1934, the University of Chicago, in collaboration with the Chicago Department of Public Health, identified 75 different community areas in the city that were connected by bus routes, streetcar lines, subways, and the elevated train, called the "L." Within these areas, many neighborhoods developed where people spoke the same language and generally attended the neighborhood church or temple. The poorest areas, with the exception of the Gold Coast, edged the downtown area called the Loop.

Deprivation invaded the lives of the homeless, the poor, and the middle class. Bruno Gliwa from Pilsen, who endured the Great Depression, said, "As kids in our neighborhood, we were all in the same boat. Nobody had it better than anyone else, so we didn't consider ourselves poor." Elmer Haas, whose parents owned a farm, declared, "What Depression? When we were hungry, we just butchered another hog." Despite these attitudes, both young men wanted to work, but

jobs were scarce. Gliwa joined the Civilian Conservation Corps (CCC), a New Deal project in which young men could earn $30 dollars a month doing public works throughout the United States; $25 was automatically sent home to the families.

Other New Deal agencies were developed to create jobs, as well. The Works Progress Administration (WPA) fostered the arts by hiring artists, photographers, dancers (like Katherine Dunham), writers (including Studs Terkel), and architects. It also built housing for families; the Jane Addams Homes and the Ida Wells Homes were built in Chicago. The Farm Security Administration (FSA) documented the Depression throughout the country, including Chicago, with photographs, many of which are included here. Building projects, like the Outer Drive Bridge and DuSable High School in Chicago, were enabled by the Public Works Administration (PWA.) Many of these New Deal agencies were housed at Navy Pier.

While listening to FDR on the radio during his "fireside chats," some Americans felt that he understood their predicaments. During his presidency, he gave 30 radio speeches from the White House near his fireplace; but the radio connected people to more than the president. Remote broadcasts could be heard from Chicago ballrooms like the Aragon, the Edgewater Beach Hotel, the Congress Plaza Hotel, and the Palmer House. Jazz was hot in Bronzeville (a 1990s term for the Black Belt, located on the South Side), especially at the Savoy, where people could dance almost every night of the week. WMAQ Radio Chicago hosted the comedy *Amos 'n' Andy*, while NBC Radio Chicago aired *The Fibber McGee and Molly Show*. The airwaves were capable of bringing uplifting joy into homes; by 1933, most Americans owned a radio.

For those who were able to explore the city, Chicago provided cultural attractions and many free venues, as well as building projects to create easy access to community areas. The Lake Shore Drive Bridge (also called the Outer Drive Bridge or the Link Bridge) opened in 1937, connecting North and South Lake Shore Drive and easing the traffic flow on Michigan Avenue. The Chicago Park District merged 22 independent parks into a single agency in 1934 and also opened the Chicago Zoological Park (Brookfield Zoo) the same year. Many museums offered free days for the public, where one could see the stars, admire great art, or experience the cutting edge of science. The Chicago Public Library promoted reading through WPA posters and library branches located in the neighborhoods. Lake Michigan was easily accessible to the public; free beaches and harbors dotted the shoreline. Sports were ever popular; enthusiasts had access to sports stadiums like Wrigley Field, Comiskey Park, and Soldier Field.

Community centers arose around the city. The On Leong Merchant Association—called China Town's City Hall—held classes for Chinese Americans and assisted new immigrants. Churches from the South Side in conjunction with the *Chicago Defender*, an African American newspaper, assisted the Great Migration of people from the American South. Many communities held painting classes, had boxing lessons, gave swimming lessons, and even provided shuffleboard.

By 1941, when America entered World War II, industrial jobs opened up, bringing many to work, especially women. Throughout the Depression, women held down the households despite privation; but the lack of males in the workforce, due to service, allowed females to participate in the war effort. Chicago stood strong against the hardships of the Great Depression only to shoulder another burden: sending her men to war.

One

MOBSTERS AND MARTINIS

""They tell me you are wicked and I believe them . . ."
— Carl Sandburg

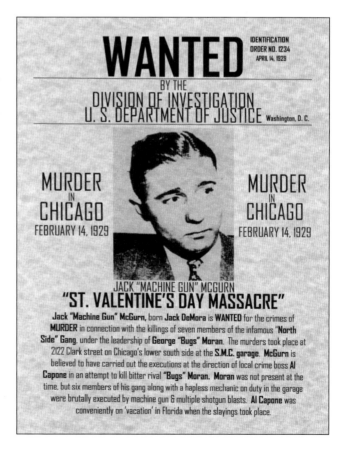

Unemployment and fallout from the stock market crash plagued America. Meanwhile, in Chicago, a bitter gang war was brewing, culminating with the St. Valentine's Day Massacre. Capone's South Side gang allegedly committed the grizzly crime. Capone was in Florida, but Jack McGurn was arrested and questioned. Thanks to McGurn's girlfriend, Louise Rolfe, his blonde alibi, he was released from custody. Ironically, McGurn was killed on Valentine's Day, 1936.

WANTED

IDENTIFICATION ORDER NO. 1234
APRIL 14, 1929

BY THE
DIVISION OF INVESTIGATION
U. S. DEPARTMENT OF JUSTICE Washington, D. C.

MURDER IN CHICAGO FEBRUARY 14, 1929

MURDER IN CHICAGO FEBRUARY 14, 1929

JACK "MACHINE GUN" MCGURN
"ST. VALENTINE'S DAY MASSACRE"

Jack "Machine Gun" McGurn, born Jack DeMora is WANTED for the crimes of MURDER in connection with the killings of seven members of the infamous "North Side" Gang, under the leadership of George "Bugs" Moran. The murders took place at 2122 Clark street on Chicago's lower south side at the S.M.C. garage. McGurn is believed to have carried out the executions at the direction of local crime boss Al Capone in an attempt to kill bitter rival "Bugs" Moran. Moran was not present at the time, but six members of his gang along with a hapless mechanic on duty in the garage were brutally executed by machine gun & multiple shotgun blasts. Al Capone was conveniently on 'vacation' in Florida when the slayings took place.

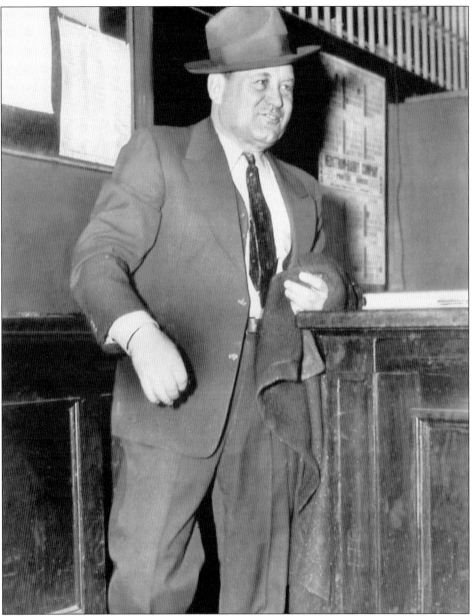

George "Bugs" Moran, originally a safecracker and petty thief, became the boss of the North Side gang in 1927. Madison Street was the division line between his and Capone's territories. Both men were bitter enemies, vying for control of the city. In 1929, at the SMC Cartage Company warehouse run by Moran, four men—two dressed as police and two men in civilian clothes—entered the warehouse where seven of Moran's men were meeting. Moran spotted a police car earlier, so he did not attend. The men inside were lined up against a brick wall and gunned down. More than 200 bullets were fired; at least 100 of them were found in the men. Capone, who was in Florida at the time, was questioned. He replied, "The only man who kills like that is Bugs Moran." After the St. Valentine's Day Massacre, Moran's organization was destroyed, leaving Capone as the number-one boss of the entire Chicago Outfit. He was enabled by an easily bribed, extremely corrupt city government.

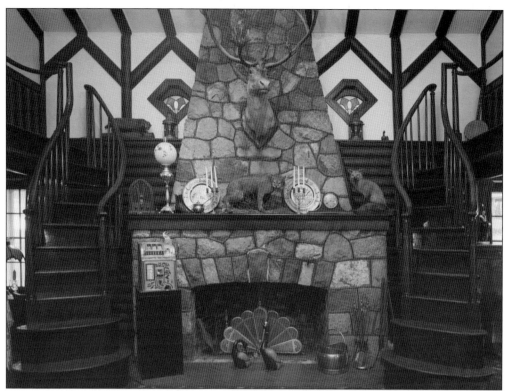

Al Capone was a millionaire by the age of 21. By 1927, he was worth $100 million, earning his money, according to the FBI, through racketeering, bootlegging, gambling, bribery, narcotic trafficking, robbery, and murder. Shown here is the living room of his hideout in Wisconsin. His men unloaded smuggled liquor off seaplanes from Canada, which landed in his private lake. The liquor was destined for Chicago. (Courtesy of Carol M. Highsmith Archive, LC, P&P DIV.)

Thomas Wright "Fats" Waller, known for his tune "Ain't Misbehavin'," was playing a gig at the Sherman Hotel in Chicago. Leaving the hotel one night, Waller was kidnapped and taken to Al Capone's birthday party at the Hawthorn Inn. Waller was told, at gunpoint, to sing and play the piano, so he did. Three days later, he returned to the Sherman with a hangover, no sleep, and pockets full of money. (Courtesy of LC.)

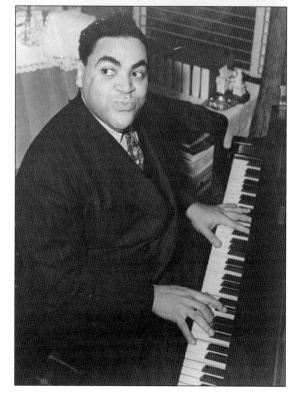

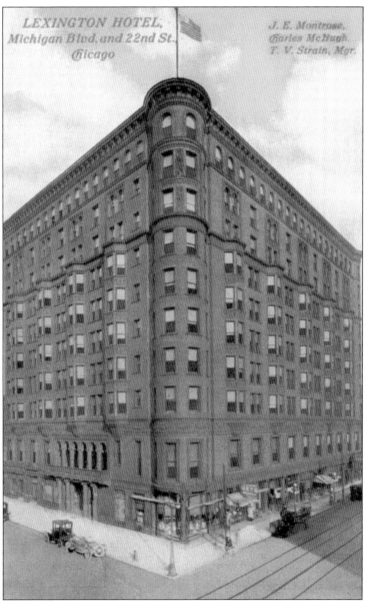

LEXINGTON HOTEL,
Michigan Blvd. and 22nd St.
Chicago

J. E. Montrose,
Charles McHugh
T. V. Strain, Mgr.

The Lexington Hotel, located at 2135 South Michigan Avenue and Cermak Road, was a residential hotel that served as Capone's headquarters from 1928 to 1933; he occupied the third, fourth, and fifth floors. His office and command center was called the "Room of Doom." With bodyguards like Tony "Joe Batters" Accardo and Louis "Little New York" Campagna armed with Tommy guns and other weapons, it was well fortified. However, Capone still had the use of secret stairwells that allowed him to exit the building at a moment's notice. The stairwells led to underground tunnels, which were used to shuttle coal and bootleg booze throughout the city. One of the stairwells opened behind the medicine cabinet in his suite and led upstairs to the rooms of his mistress. They lived in luxury. Capone's suite featured walls plastered in gold and red, an ancient oriental rug, a fake fireplace with a built in radio, and a lavender bathtub. All this was to provide a regal atmosphere for "Snorky," which was Capone's preferred nickname and meant "snappy dresser." (Courtesy of John Chuckman.)

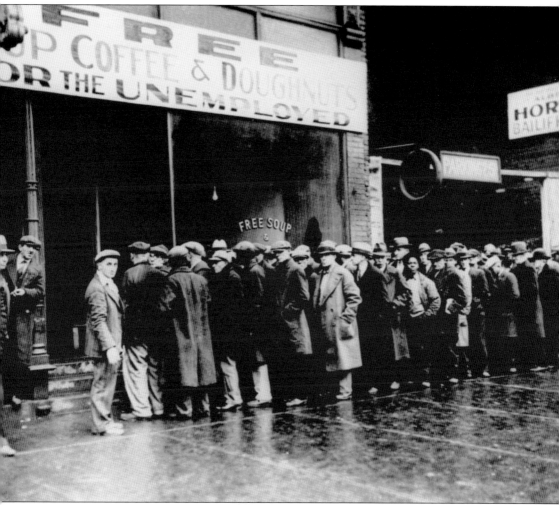

At the onset of the Depression, Al Capone had opened a soup kitchen in Chicago. Men lined up daily. The food they received, sometimes referred to as "Hoover stew," could often be the only meal they had in a day. There were more than 12 million unemployed in the United States; many of them came to Chicago from the American South and elsewhere looking for work. Also, by 1932, many firemen, policemen, and teachers who had not been paid for eight months were fired in Chicago. Some said that Capone wanted to ensure that the hungry had hot meals; he also wanted to clean up his dark image around Chicago. However, it was not difficult for the Outfit to recruit such men into their ranks. Many homeless people lived in relief shelters, while some camped out under Wacker Drive and, still, others lived in Hoovervilles (camps they created) in public parks. Steady pay earned by theft, numbers running, or gambling looked awfully good to men who felt the shame of being destitute. (Courtesy of NA&RA.)

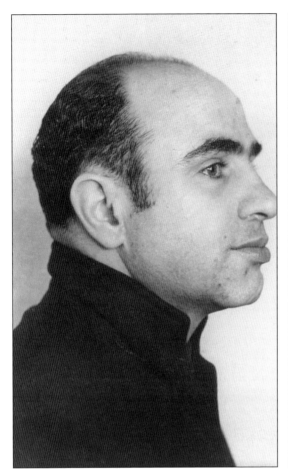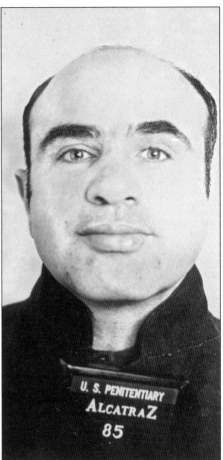

Eliot Ness (not pictured) became the chief investigator for the Department of Alcohol, Tobacco, Firearms, and Explosives for the United States Department of Justice. He was never an FBI agent. He headed a team of nine investigators to disrupt Capone's operation. Because the team could not be bribed, they became known as "the Untouchables." Finally, Capone was charged with Income tax evasion. On November 24, 1931, Capone was sentenced to federal prison in Atlanta; he paid a $50,000 fine and was charged $7,692 for court costs. The interest on back taxes came to $250,000. Eventually, he moved to Alcatraz, spending five years in cell 85. Seen here are his two mug shots. Released after serving 7 years, 6 months, and 15 days of his 11-year sentence, he never returned publicly to Chicago. He died in 1947. (Both, courtesy of FBI/USDOJ.)

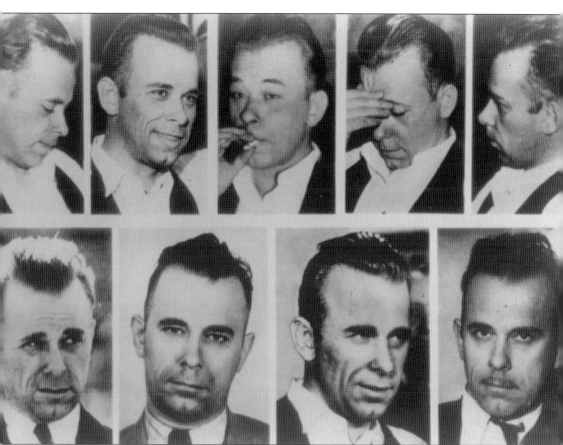

John Dillinger was known as one of the "Robin Hood Bandits" who roamed the Midwest. America's romance with gangsters of the day reflected the loss of confidence in the government. This desperado robbed 20 banks and killed 10 men, but he was a celebrity to many people. His many faces reflect the attempts he made to alter his identity with botched plastic surgery. Dillinger's gang consisted of seven out of the ten most wanted criminals. As Public Enemy No. 1, his main hideout was in Chicago. He was quoted as saying to the depositors of one bank, "Those few dollars you lose here today are going to buy you stories to tell your children, this could be one of the big moments in your life. Let's don't make it your last." (Courtesy of FBI/USDOJ.)

WANTED

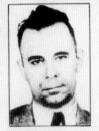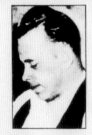

JOHN HERBERT DILLINGER

On June 23, 1934, HOMER S. CUMMINGS, Attorney General of the United States, under the authority vested in him by an Act of Congress approved June 6, 1934, offered a reward of

$10,000.00

for the capture of John Herbert Dillinger or a reward of

$5,000.00

for information leading to the arrest of John Herbert Dillinger.

DESCRIPTION

Age, 32 years; Height, 5 feet 7-1/8 inches; Weight, 153 pounds; Build, medium; Hair, medium chestnut; Eyes, grey; Complexion, medium; Occupation, machinist; Marks and scars, 1/2 inch scar back left hand, scar middle upper lip, brown mole between eyebrows.

All claims to any of the aforesaid rewards and all questions and disputes that may arise as among claimants to the foregoing rewards shall be passed upon by the Attorney General and his decisions shall be final and conclusive. The right is reserved to divide and allocate portions of any of said rewards as between several claimants. No part of the aforesaid rewards shall be paid to any official or employee of the Department of Justice.

If you are in possession of any information concerning the whereabouts of John Herbert Dillinger, communicate immediately by telephone or telegraph collect to the nearest office of the Division of Investigation, United States Department of Justice, the local addresses of which are set forth on the reverse side of this notice.

JOHN EDGAR HOOVER, DIRECTOR, DIVISION OF INVESTIGATION, UNITED STATES DEPARTMENT OF JUSTICE, WASHINGTON, D. C.

June 25, 1934.

FBI agent Melvin Purvis (not pictured) had been tracking Dillinger from Indiana, to Wisconsin, and finally to Illinois. Dillinger was staying in Chicago with Polly Hamilton, his girlfriend. Hamilton's landlady, Anna Sage, an immigrant from Romania, was about to be deported, so she made a deal with Purvis to help arrest Dillinger. On July 2, 1934, Hamilton, Sage, and Dillinger made plans to go to the Biograph Theater, where *Manhattan Melodrama* (a gangster movie) was playing. Sage's dress had a red glow under the marquee lights as they exited the theater; she was thereafter called "the lady in red." Purvis saw the trio, lit a cigar as a signal to his agents, who went after Dillinger; he ran into an alley. There, he was shot to death. The FBI double-crossed Sage, who was eventually deported. (Both, courtesy of FBI/USDOJ.)

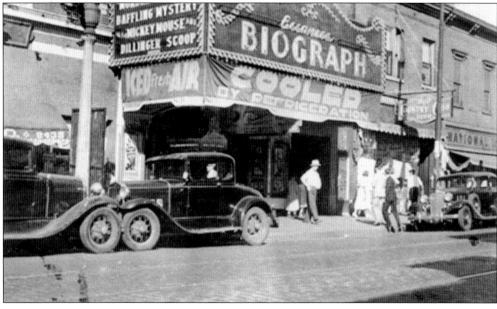

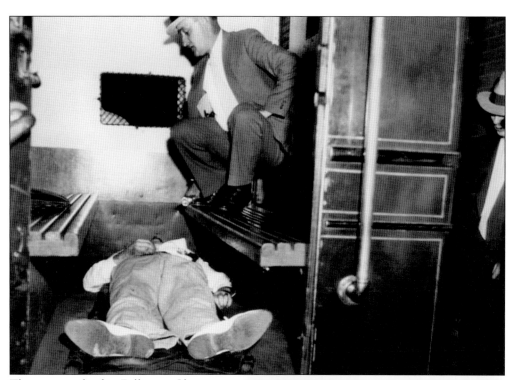

Three agents fired at Dillinger: Clarence Hurt, Herman Hollis, and Charles Winstead. None of them ever said whose shot killed him. His body was placed on the floor of a paddy wagon for transportation to the hospital (above). At 10:50 pm, John Dillinger, age 31, was pronounced dead at Alexian Brothers Hospital. His death ended Chicago's romance with criminal heroes. Movies like the last one Dillinger saw had glamorized the gangsters. Actors like Clark Gable presented the criminals as vulnerable and slightly flawed. This real image of death marked the end of the golden age of gangsters. The original death mask of Dillinger, depicted here, can be seen at the Museum of Crime and Punishment in Washington, DC. (Above, courtesy of FBI/DOJ; right, photograph by Jewelr07, courtesy of CC by SA.)

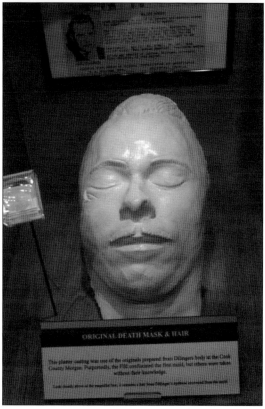

ORIGINAL DEATH MASK & HAIR

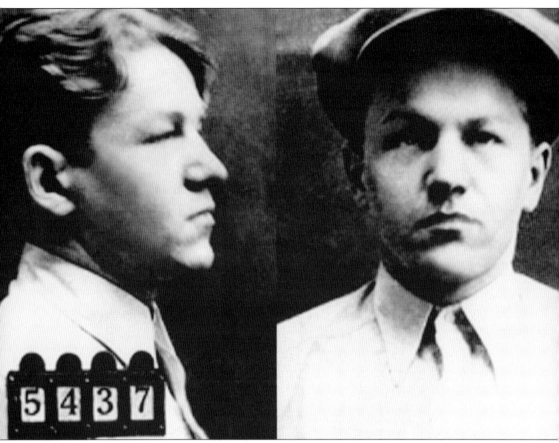

Better known as "Baby Face" Nelson because of his juvenile appearance, Lester M. Gillis (pictured) was born in Chicago in 1908. In 1931, he was sentenced to Statesville Penitentiary in Joliet, Illinois, but escaped in 1932. Recruited by Dillinger's gang, he was involved in a robbery that resulted in murder. After Dillinger's death, Special Agent Herman Hollis and Inspector Samuel Crowley confronted Nelson and John Chase in Barrington, Illinois, beginning with an automobile pursuit. Nelson fired automatic weapons into the agents' car. A gun battle ensued; Hollis, Crowley, and Nelson were mortally wounded, but Chase got away and left the state. On December 31, 1934, Chase was taken back to Chicago and convicted of murdering Inspector Samuel P. Crowley; he was sent to Alcatraz. Later, he was remanded to Leavenworth until he was paroled in 1966. John Chase died in 1973. (Courtesy of FBI/USDOJ.)

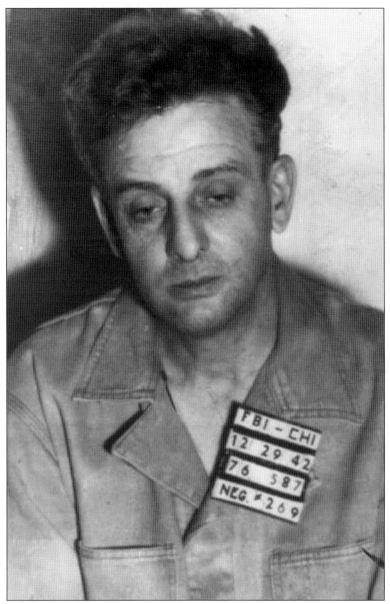

Roger "the Terrible" Touhy's territory included the northwest section of Cook County for five years. However, in the late part of 1933 and early 1934, his gang was taken down. Touhy (pictured) and Basil "the Owl" Banghart were convicted (in separate trials) in the state court in Chicago in 1934 and sentenced to 99 years in prison for kidnapping Jake "the Barber" Factor and holding him for ransom. Later, Touhy and Banghart were together in the state penitentiary in Joliet, Illinois. For seven years, they were able to keep in touch with their outside contacts through an elaborate underground grapevine, waiting for a chance to escape. Their chance came in 1942, when Touhy and Banghart, with plans to break out, took another inmate, "Big Ed" Darlak, into their confidence because his brother Casmir, who was on the outside, would be able to acquire guns. Casmir placed revolvers under some bushes near the penitentiary. Later, the guns were smuggled in by a trustee who had the duty of lowering the outdoor flag each evening. He carried in the guns wrapped in the flag. (Courtesy of FBI/USDOJ.)

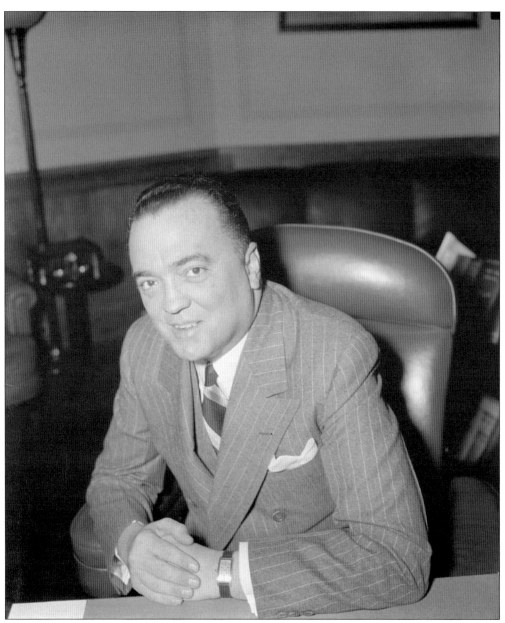

After Touhy's jailbreak in 1942, J. Edgar Hoover (pictured) became personally involved in the hunt for the criminals only after they had committed a federal crime (the prison escape was a state crime). The FBI pursued the gang after they failed to register for Selective Service, a federal offense. The gang had been hiding out in various places in Cook County, such as the forest preserves, where they foraged for food. But eventually, after stealing a car, they holed up at 5116 Kenmore Avenue in Chicago. Hoover raided the location. On December 29, 1942, Touhy, Banghart, and Big Ed Darlak were captured and returned to jail. According to the FBI files, Touhy said, "You're Mr. Hoover, aren't you? I pegged you from your picture in the paper. It's not everybody that has the honor of having the big Chief get him." When asked what Touhy was thinking, Banghart said, "Well, Boss, he's thinking as Molly said to Fibber the other night—it ain't funny anymore." (Photograph by Harris and Ewing, courtesy of LC.)

Edward J. Kelly was appointed as mayor of Chicago after the assassination of Mayor Anton Cermak in 1933. It took an act of the state legislature to permit Kelly, a non-alderman, to fill the vacancy. Kelly became part of the most powerful, almost corrupt, big-city government. Patrick A. Nash, the Cook County Democratic Party chair, allied with Kelly to create the "Kelly-Nash [Democratic] Machine." Gambling and organized crime ran rampant, and Kelly was said to have tapped into the resources of organized crime. Above, Kelly is seen outside the White House in 1937; he supported Roosevelt, bringing in majorities for his election. In return, Kelly obtained many New Deal social and welfare programs for Chicago. Right, a view into city hall, photographed by Dorothea Lange, shows part of the city council that supported Kelly during the Depression. (Both, courtesy of LC.)

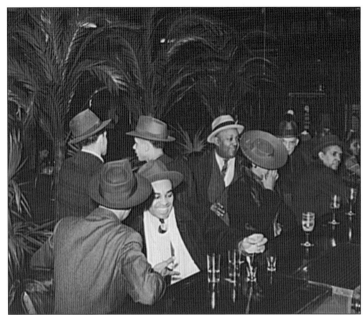

The original owner of the Palm Tavern, at 446 East 47th Street in Bronzeville, was James "Genial Jim" Knight. Considered to be one of the "policy barons," he promoted "the numbers game," an illegal form of gambling. The tavern was a famous hangout for the city's black gangsters, but it also attracted great musicians, artists, and writers, as well as the African American middle class. (Photograph by Russell Lee, courtesy of LC.)

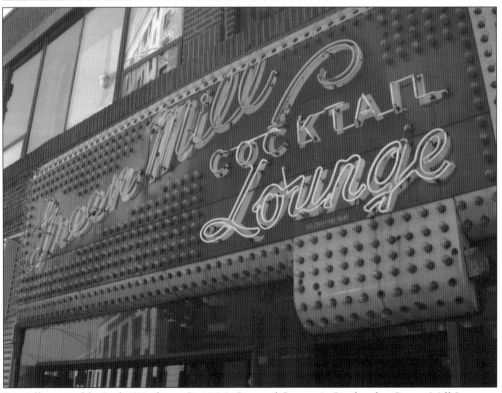

Partially owned by Jack "Machine Gun" McGurn of Capone's Outfit, the Green Mill Lounge, located at 4802 North Broadway Street, was one of Capone's favorite speakeasy hangouts. The secret escape tunnels under the building allowed the mobsters to escape raids by the police or other gangs that might occur. Today, the Green Mill is a popular venue for jazz and poetry readings in the Uptown neighborhood. (Photograph by Keith Cooper.)

The Berghoff Restaurant, situated at 17 West Adams Street, sold near beer (brewed beer in which the alcoholic content was removed) during Prohibition. Also known for its excellent German cuisine, it created Bergo soda pop, its famous root beer that is still sold today. After the repeal of Prohibition, Berghoff acquired the first liquor license in the city. (Courtesy of Carol M. Highsmith Archives, LC, P&P DIV.)

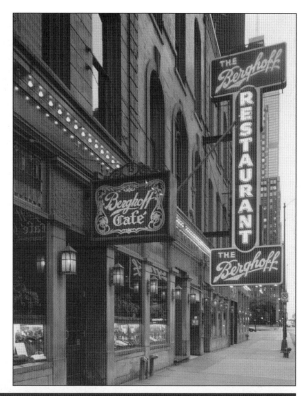

The repeal of Prohibition made it legal to sell and serve alcohol. Breweries that once brewed near beer could now openly brew the real thing. The Pabst Brewing Company had a sales office in Chicago. This sign advertised Pabst Blue Ribbon Beer (it won a blue ribbon in the 1893 Chicago world's fair) and stood over the rail yards where Millennium Park is today. (Photograph by Jack Delano, courtesy of LC.)

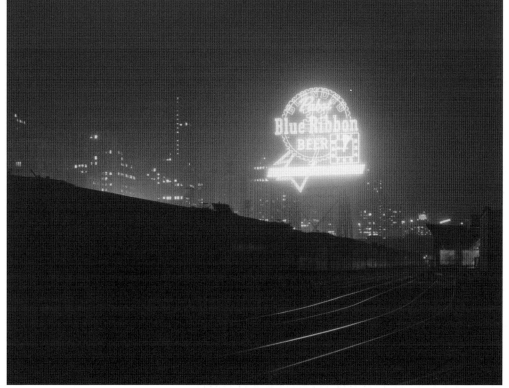

The Peter Schoenhofen Brewery, located at West 18th Street and Canalport Avenue in Pilsen, became one of the breweries to operate during the dry years of Prohibition. They barely survived by bottling soft drinks and cereal beverages like near beer. Prohibition ended on December 5, 1933. It was the first time in US history that an amendment was made (the 21st) to repeal another amendment (the 18th). It was left up to the states to decide about alcohol within their borders. Special state conventions were called to ratify this amendment; it was not ratified by state legislatures. This new law cut into the mob's income, as they no longer needed to bootleg liquor into Chicago. "Personal Responsibility Day," celebrated at the World's Fair, marked the passing of Prohibition. Mayor Kelly arranged to have 2,000 barrels of beer and 20,000 sandwiches free for anyone who braved the cold Chicago weather. The Schoenhofen brewery, which originally created Edelweiss beer, was back in business as the Schoenhofen-Edelweiss Company and continued to be one of Chicago's legitimate breweries. (Courtesy of LC.)

Two

A CITY OF PROMISE

"Building, breaking, rebuilding . . ."
— Carl Sandburg

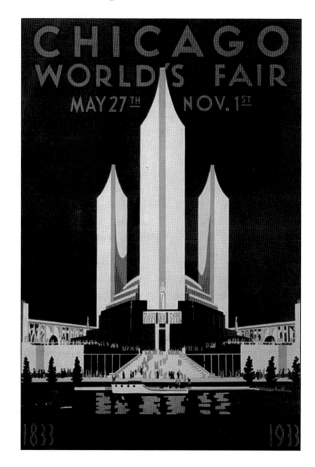

The 1933 World's Fair was so successful that it was extended to 1934, providing jobs for many Chicagoans, such as guides, maintenance crews, laborers, security guards, vendors, transportation workers, restaurateurs, entertainers, architects, and artists, to name a few. This Art Deco–style silk-screened poster, created by Weimer Pursell, was only one form of marketing used to promote the fair. Pursell studied at the Art Institute of Chicago. (Courtesy of LC.)

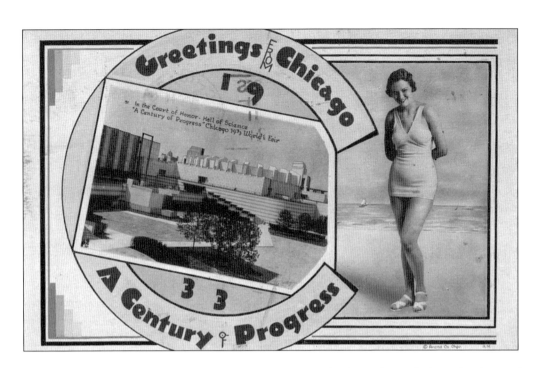

In the Court of Honor: Hall of Science "A Century of Progress" Chicago 1933 World's Fair

It cost 50¢ to enter the Century of Progress Exposition, which was located along the shore of Lake Michigan, edging Chicago. In 1933, 22 million visitors attended the fair. Even though it provided jobs for some, it was meant to provide hope for other Chicagoans who were out of work. The unemployed numbered about 600,000 people, or 40 percent of the workforce. For those who could not afford a ticket, free days were provided. Many people went to the Food Building, where companies provided food samples and free token souvenirs. For others, consumer spending was promoted. There were splendid stores and restaurants where people could shop and dine. Many of the rides and shows required an extra fee. (Above, courtesy of John Chuckman; below, courtesy of Regina Ziemann.)

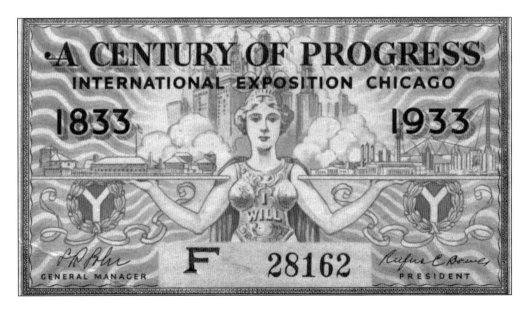

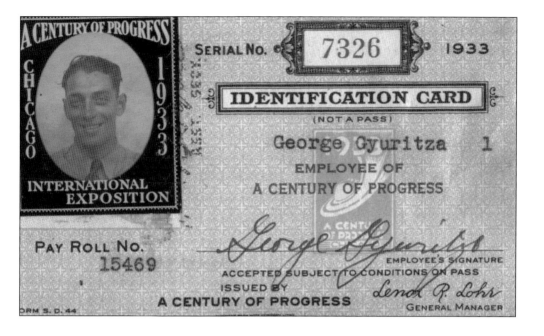

George Gyuritza, looking for work, applied at the World's Fair. He noticed during the interviews that "college men" were preferred, and he was not one of them. Jobs were scarce, and he wanted one. The fair was taking only the best. When Gyuritza was asked what college he attended, he said, "Georgetown." As a result, he got a job and worked for three years: two years as a guide, and one year removing the exposition. Because of the job, Gyuritza, shown in his official guide uniform (standing with bent knee), and his wife, Regina (on his right), were able to rent an apartment in Roseland at 139 East 103rd Place. (Both, courtesy of Regina Ziemann.)

Beauty queens played a significant role in the World's Fair. In 1933, a call for entries caught the attention of women across the country. The competition to select the Century of Progress Queen was not marketed as a beauty contest; ads specifically stated that the women would be judged on charm, grace, and character instead. Fourteen nationwide newspapers collected photographs of entrants into the pageant and sent them to the *Chicago Tribune* for judging. Fifty-one winners were awarded a two-week trip to Chicago, all expenses paid, plus gowns to wear at the ceremonies as they represented the queen's court. The queen was awarded $5,000, and each girl in the court was given $100 for having her photograph published in the *Tribune*. The chosen queen for 1933 was Lillian Anderson of Racine (above). In 1934, the queen was selected from 800 beautiful women employed at the fair. Queen Patricia Marquam, age 24, is seen below (back row, third from right) being driven throughout the fair in a convertible with members of her court. (Above, courtesy of Critical Past; below, courtesy of John Chuckman.)

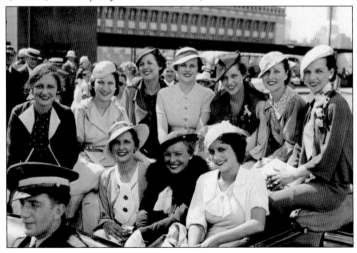

There were other contests connected to the Century of Progress fair. Pageants could be very lucrative for the women who participated and often led to employment. The participants could not be married, widowed, or divorced. This 19-year-old law student was elected Miss Chicago in a citywide contest at the 1934 World's Fair. Alice Jaglowski, an accomplished portrait painter, pianist, and dancer was awarded a season's contract with the Ziegfeld Follies.

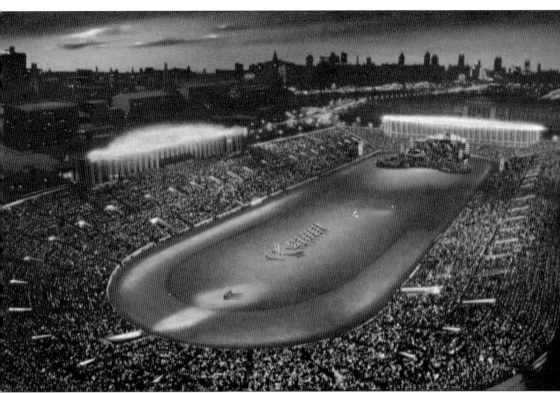

The opening ceremonies took place in Soldier Field on May 27, 1933. A great parade of people entered the arena while blimps hovered, rockets burst, airplanes roared, and music from the American Legion band played "The Artillery Song." Dignitaries included Gov. Henry Horner, Maj. Edward Kelly, and Postmaster General James R. Farley. Farley was the official representative of President Roosevelt who was, at the last minute, unable to attend. Naval reserves passed in review. Cadets from the Culver Military Academy escorted queen Lillian Anderson. The queen's court of 50 girls entered the stadium on red floats escorted by cadets from the Morgan Park Military Academy and St. John's Military Academy. The parade continued with more bands, followed by national groups that included Irish, Greek, Armenian, Swiss, German, Italian, and others. Finally, rockets exploded to release flags from all nations by parachute. The Century of Progress was declared officially open.

Chicago became known as the "City of Lights" and "Rainbow City" because of the colored lights that illuminated the grand buildings, monuments, and exhibits at night. Seen here is the Illinois Host Building, glowing against the darkness of night. Buckingham Fountain, the jewel of the Lake Shore, was symbolic of the spirit of the city. Dedicated to the people of Chicago in 1927 by Kate Sturges Buckingham in the memory of her brother, Charles, it was a focal point for tourists and locals alike. Each night, beginning at dusk, a colorful display of lights, music, and water danced through the night. The beautiful lights of the exposition animated the lakefront, separating it from the stark neighborhoods of the poor and homeless.

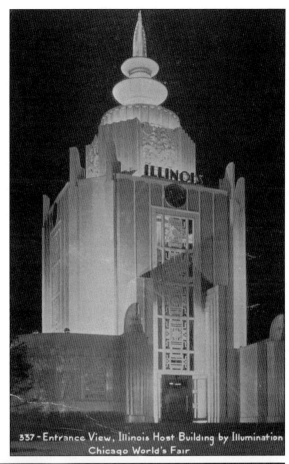

337 - Entrance View, Illinois Host Building by Illumination
Chicago World's Fair

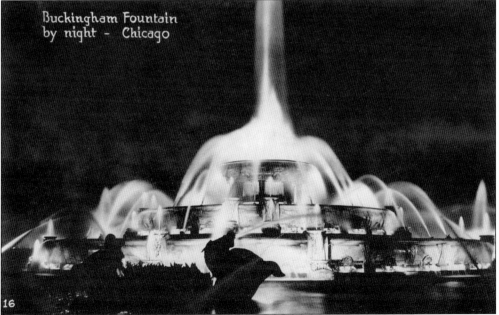

Buckingham Fountain
by night - Chicago

16

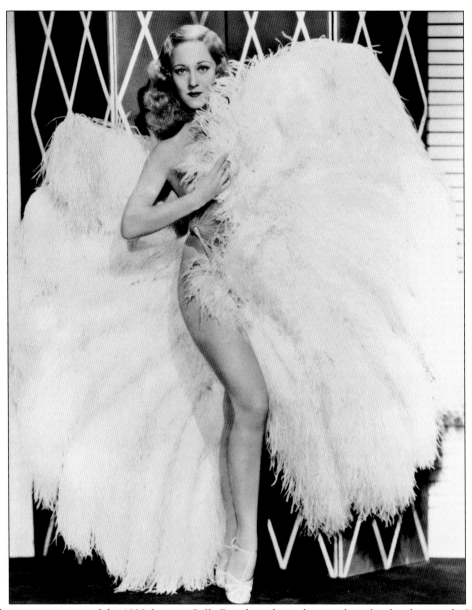

The star attraction of the 1933 fair was Sally Rand, packing the people in by the thousands. Her alluring fan dance and the illusion of nudity outraged the socialites of the community. Some say that Rand intended her performance to purposely scandalize many of the high-society matrons who disapproved of her. She even rode on a white horse, in the style of Lady Godiva, down the streets of Chicago as a publicity stunt to advertise her show. Posing in a body suit, in silhouette, and covering herself with giant pink ostrich feathers, she created a very evocative performance at the Streets of Paris exhibit on the Midway. In fact, she was even arrested several times on the same day for her lewd behavior. Superior Court Judge Joseph B. David dismissed the morals charges that were pressed against her for "want of equity," allowing her to perform with impunity. In 1934, she improved the show to include 24 dancers, 16 showgirls, and a giant transparent bubble in which she danced, again, seemingly in the nude. In 1966, Rand presented a pair of fans to Chicago's Historical Society.

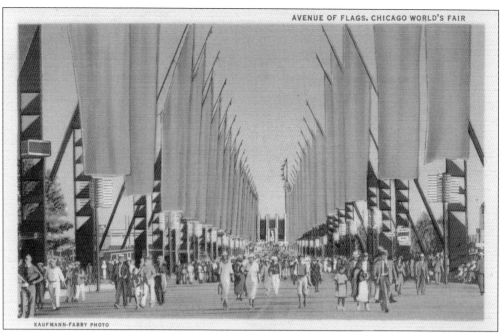

KAUFMANN-FABRY PHOTO

The Avenue of the Flags was a walkway stretching from the main gates at the North Entrance of the fair to the Hall of Science, which housed promising technology for future life in America. The avenue got its name from the rows of brilliant red flags edged in yellow. This colorful display greeted visitors and expressed the spirit of celebration with a short relief from the everyday worries. The entire exposition came to symbolize hope for Chicago and for the future of America, which was in the depths of the Great Depression.

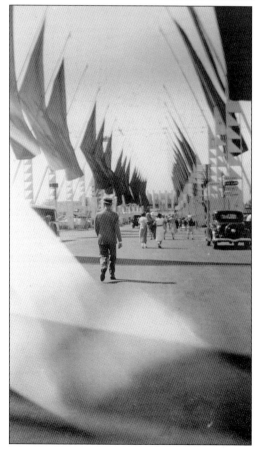

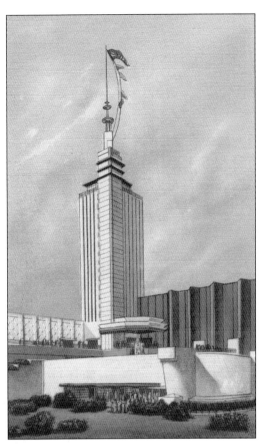

The theme of the fair was science, providing optimism to all those of the nation who visited the venue—each life could be improved by embracing technology. The motto of the fair, as written in the official guidebook, was, "Science Finds, Industry Applies, Man Conforms." Shown here is a girl approaching the Hall of Science and finding a sculpture entitled *Man Combating Ignorance*. The building itself, with its geometric lines indicative of the Art Deco or industrial design movement, was designed by Paul Cret of Philadelphia. It covered eight acres, which is approximately 400,000 square feet. The modern industrial design movement of the 1930s was meant to contrast the classical look of the 1893 fair.

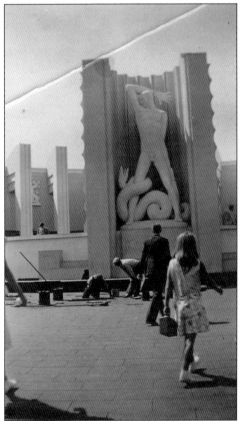

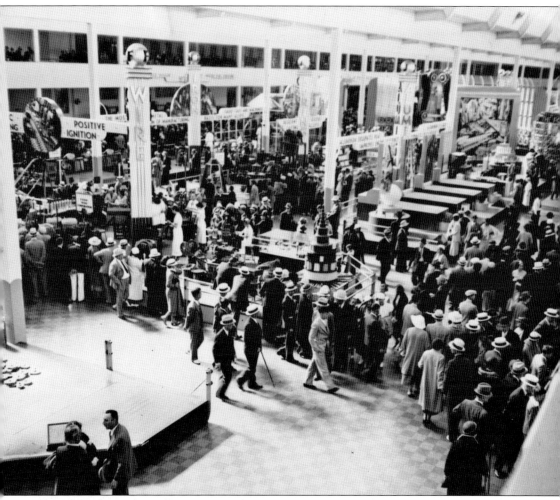

People streamed into the Hall of Science, where Union Carbide and Carbon Corporation created exhibits on both the main and ground floors; basic and applied sciences were credited as the forces that advanced the progress of modern life. The development of the electric furnace was a featured exhibit. Included as well were chemical product displays that nearly filled all of the west side of the Applied Science Exhibit, showing many of the manufactured products created by synthetic chemistry. Some of the products included were antifreeze, solvents and lacquers for paint, blending agents for high-test gasoline, long-playing phonograph records, dental plates for false teeth, and photographic film. A Vinylite house announced the Age of Plastics to the amazement of the public. Synthetic molding compound experiments were pioneered by Union Carbide and Carbon Corporation. An entire house was constructed almost entirely from vinyl. Visitors could take home a booklet entitled *Giants of the New Age* to remind them that "beneath the surface of modern life, the gigantic forces of Science move on quietly, steadily."

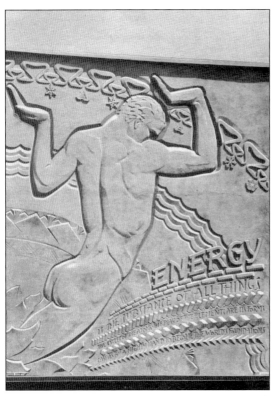

Bas-reliefs on the exterior of the Electrical Building connote energy and light. One relief represents atomic energy; it says, "Energy is the substance of all things the cycles of the atoms, the play of the elements are in forms cast as by a mighty hand to become the world's foundations." The relief above the entry represents "the conquest of time and space." The interior of the building presented displays "portraying the generation, transmission, distribution and utilization of electricity," as denoted in the building's official handbook, entitled *Electricity at Work*. The building contained an electrified home of the future, the revolution of farming using electricity, a model hospital operating room fully lit and equipped with modern advances, fluorescence, and magnetic radiation, among many other displays, which were all meant to illustrate how and why the future would be brighter.

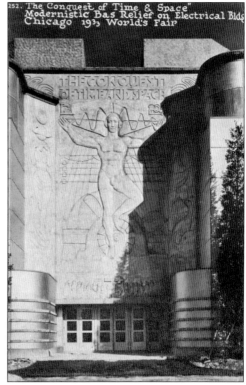

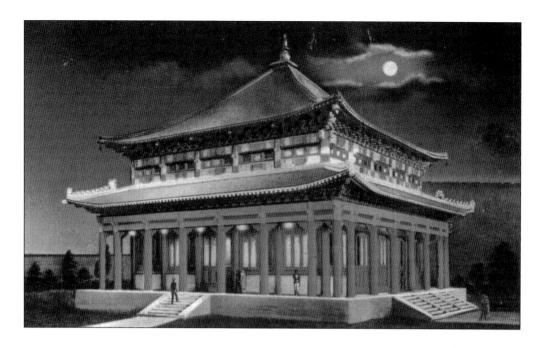

The Temple of Jehol, also known as the Lama Temple, was built in China and shipped to Chicago in 28,000 pieces to be reassembled at the exposition. This "Golden Temple," covered with $25,000 worth of 23-karat gold leaf, was the place of worship for the Manchu Emperors and was copied faithfully by North Chinese architects. It was a gift of Vincent Bendix, an exposition trustee, to the World's Fair. Inside, a gilded ceiling was supported by twelve 37-foot-tall columns. The temple contained objects of ritual and treasures such as an antique wooden sculpture of Buddha, jewels, and carved jade. If visitors were able to buy tickets in advance, they would obtain a stub that allowed them to enter the exhibit for free. In 1933, only 46 percent of those visiting the temple paid cash to enter. (Below, courtesy of Regina Ziemann.)

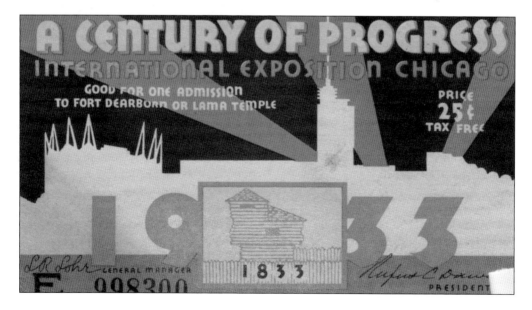

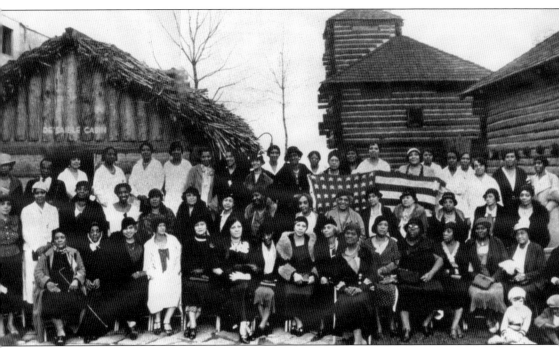

Despite the strain of the Great Depression, Annie E. Oliver and the Women of the De Saible Memorial Society, as it was known in 1933 (the spelling was later changed to DuSable), spent five years raising funds to build a replica of the DuSable cabin for the Century of Progress Exposition, as seen on the left. The women built the cabin to be one-third the size of the original, which was situated on the mouth of the Chicago River around 1774. The replica stood eight feet by twelve feet and was based on an 1884 engraving by A.T. Andrews. The exhibition was meant to educate the public that it was Jean Baptiste DuSable, the son of a Haitian Frenchman and an African slave, who selected the location that is now Chicago. Because of his foresight, he made his fortune through a trading post and successful farm that launched Chicago, then called Eschikago, as a future commercial center. This exhibit supported the pride of African Americans by demonstrating the achievements of DuSable as the city's founder. (Courtesy of the Vivian G. Harsh Research Collection of Afro-American History and Literature, George Cleveland Hall Branch Library Archives, Chicago Public Library.)

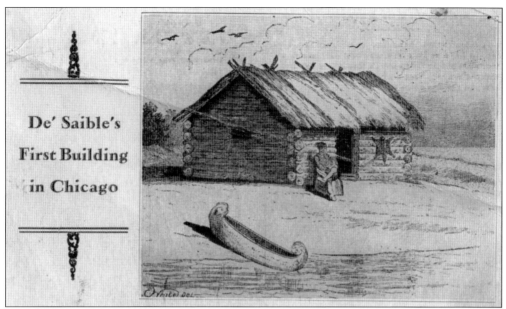

De' Saible's First Building in Chicago

The DuSable cabin was situated at the junction of the Chicago River and Lake Michigan. This engraving, by A. Ackerman and Sons, depicts the site as it was in 1779. DuSable traded goods with Native Americans, trappers, and Europeans who were looking for access to the Mississippi River. Eventually, the homestead developed into a settlement, where DuSable and his family lived for at least 20 years.

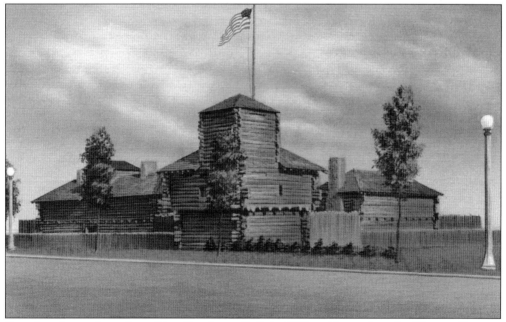

Seen here is a scale replica of Fort Dearborn. Built in 1803 and located on the Chicago River, it was named after Secretary of War Henry Dearborn. In 1939, the Chicago City Council placed a fourth star on the city's flag to commemorate Fort Dearborn and the battle of 1812, in which the fort was destroyed by Pottawattamie Indians. Rebuilt in 1816, it protected settlers against further Indian attacks.

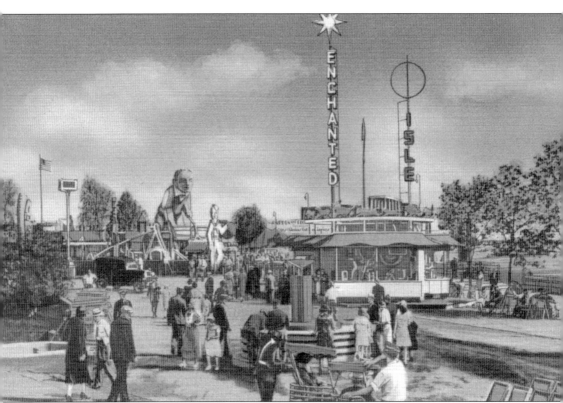

Entry to the Enchanted Island, a five-acre "fairy land" created for children, was included in the general admission to the exposition. There were games, plays by the Junior League, classes in doll's dressmaking, folk dancing, and all sorts of handicrafts to occupy the young ones. In fact, parents could leave their children at the island as they enjoyed the fair. Junior fair guides, with special training in childcare, provided a four-hour tour of the island, complete with meals prepared by expert dieticians. Parents were encouraged to give their children a few pennies or small change to spend on their tour of the exhibits, which included a real farm with animals, a house made of marbles, a giant Radio Flyer wagon, and a Magic Mountain to climb. If parents were late to pick up their children, they would find them napping in special nooks, refreshing themselves for the rest of the day.

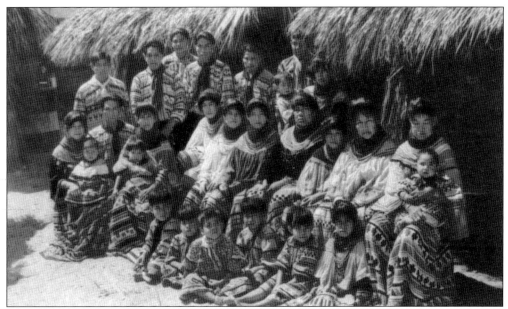

A group of Native Seminole Americans came to Chicago from Florida to recreate an authentic village. The sign over the village advertised alligator wrestling, an activity the Seminoles practiced in Florida. They are seen in their traditional dress, which was created by sewing small pieces of colorful fabric together to make unique designs. The Seminoles were considered to be strong-spirited people who stayed in touch with their traditions.

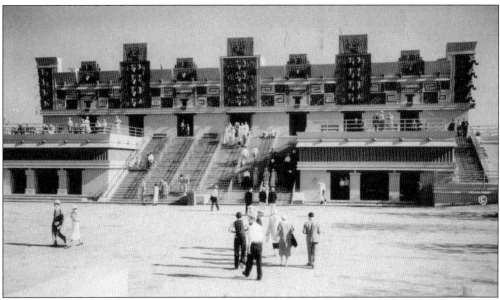

The Maya Temple at World's Fair was modeled after the Nunnery at Uxmal, Yucatan. The Nunnery was named by Spaniards friars, who visited Uxmal in 1588, because they were told that the building was once occupied by maidens who tended sacred fires in the temple. They vowed chastity and continual feeding of the flames. Death was the punishment for breaking their vows.

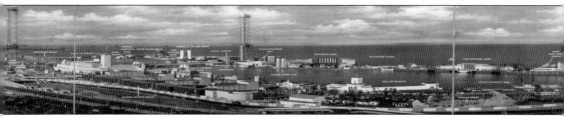

The fairgrounds covered about 424 acres of land, including two man-made lagoons and Northerly Island. The island, a strip of reclaimed land just southeast of the Loop, juts into Lake Michigan with a landmass of 91 acres. Adjacent to the shore of Lake Michigan, the fair extended between 12th and 39th Streets, south of Navy Pier. (Today, Northerly Park and McCormack Place are found on this site.) Immediately north of the exposition grounds was Grant Park. Some permanent features

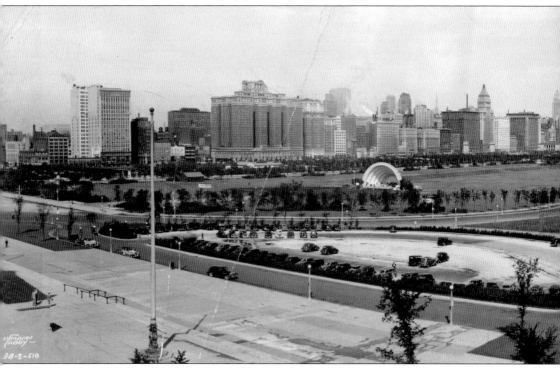

This view of Grant Park, the Chicago Skyline, and the lakefront are seen looking north toward Navy Pier. The prominent feature to the left of the image is the band shell, which was used for free concerts during the Chicago World Exposition. Created in 1931, it was meant to provide a free venue for the people of Chicago to enjoy entertainment and to provide musicians with paying jobs. By 1935, James C. Petrillo, president of the Chicago Federation of Musicians, convinced the

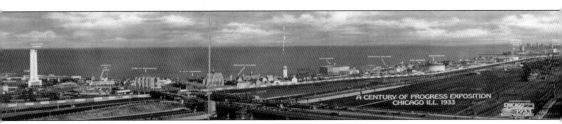

included in the exposition activities were Shedd Aquarium, Alder Planetarium, Soldier's Field, and Buckingham Fountain. The fair, with its mammoth buildings, extended for miles, making it impossible to see it entirely in one day. Visitors were encouraged to take intramural buses for transportation between buildings and exhibits. (Courtesy of LC.)

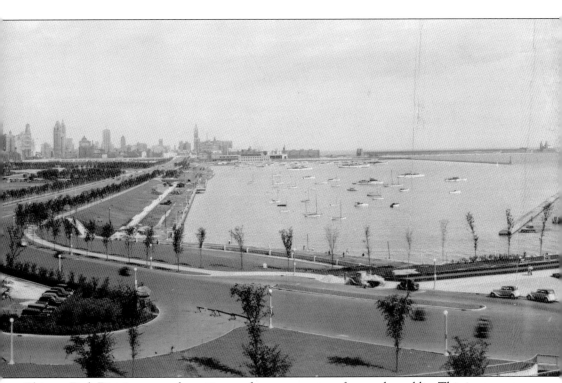

Chicago Park District to pay for a nine-week concert season free to the public. This image was taken after the Chicago World Exposition was closed. It took about a year for the lakefront to be restored to its usual appearance. Monroe Harbor, another source of recreation, is also depicted here. (Photograph by Kaufman and Fabry, courtesy of LC.)

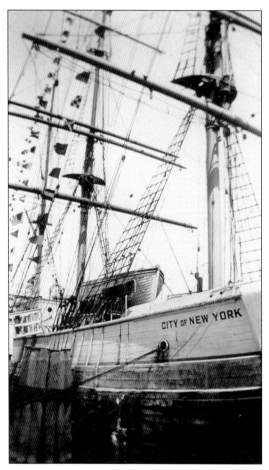

Admiral Byrd's ship, the *City of New York*, pictured left, was moored in the south lagoon. Tourists could board the ship and take a tour. It was manned by a crew of sailors, some of whom were part of Byrd's original 82-man crew that sailed over Antarctic ice floes to establish his base camp Little America, situated on the Ross Ice Barrier, from which he flew over the South Pole. Inside the ship, below deck, was a reproduction of Little America, a collection of relics of the expedition, instruments, and specimens of wild life of Antarctica. Looking south over the World's Fair grounds, two man-made lagoons can be seen to the left of the photograph below; the lagoon closest, near the Havoline Thermometer, is where the ship was moored.

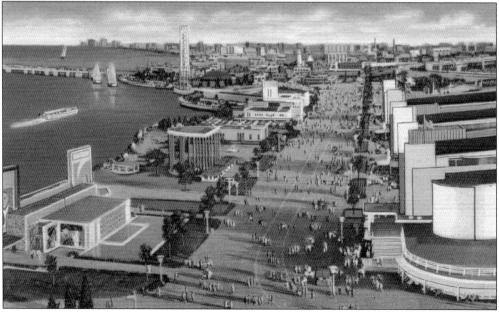

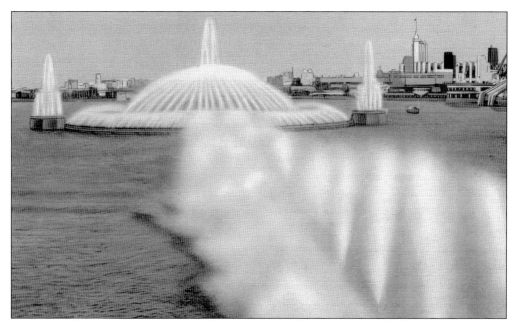

Fountains were also a feature of the lagoons. This one, a Century of Progress Fountain in the North Lagoon was the largest ever constructed. It had lighting effects in five colors: green, red, amber, blue, and white. The main feature was 40 feet high and 200 feet wide with water streams of 75 feet into the air; it expelled 68,000 gallons of water per minute through its outlets.

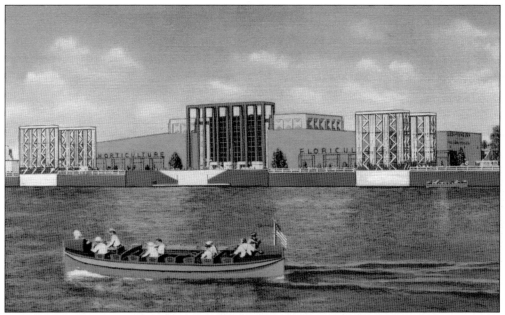

Seen here is a motorized boat used to convey the visitors by use of the lagoons across the lakefront. The facade of the Horticultural Building, facing Lake Michigan, could be thoroughly appreciated from this viewpoint and distance. Inside the building, many unusual plants and flowers were on display, making it one of the most beautiful buildings at the exposition.

The Sky Ride and Observation Towers, 625 feet above the ground, could be accessed by office building–type elevators. It was the highest structure in Chicago. From the observation deck by day, one could enjoy a panoramic prospect of the city as well as the shores of Michigan, Indiana, Illinois, and Wisconsin. At the 200-foot level, a rocket car ride over the lagoon could be experienced for 40¢ for adults and 25¢ for children. At night, the "City of a Million Lights" was an unforgettable infusion of color, light, and sound at the height of many of the nearby buildings.

The Havoline Thermometer soared 200 feet into the sky, higher than a 21-story building. The Indian Refining Company dedicated it to Chicago's climate, which all Chicagoans joke about. The saying goes, "If you don't like the weather, wait an hour, and it will change." The thermometer's temperature columns were made of neon tubing, electronically regulated by a master meter. Three faces of numerals, 10 feet high, denoted the accurate temperature both day and night. To construct the imposing, almost obelisk-like monument, 10 miles of wire, 3,000 feet of neon tubing, and 60 tons of steel were used. It was erected by makers of Havoline Motor Oil Waxfree, the "oil that protects your engine at all temperatures," according to the company's advertisements. It was a favorite meeting place for tourists because it was so easily seen.

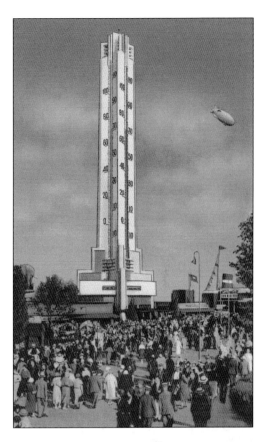

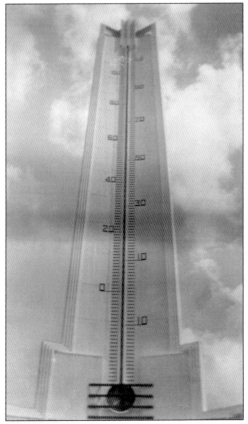

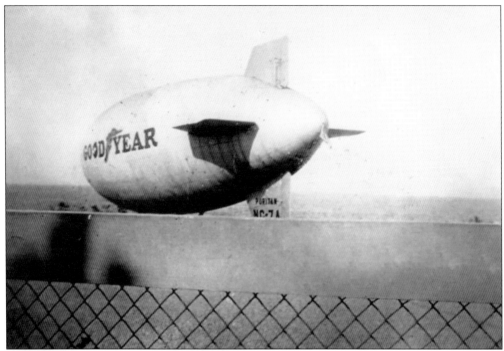

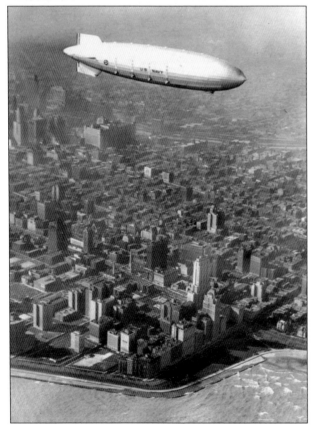

Goodyear advertised their soft-shelled, helium-filled blimp as perfectly safe for travel. In fact, six passengers at a time could ride the Puritan NC-7A, as it was called, for an extra fee. The 10-minute ride provided a panoramic aerial view of the fair and the experience of a lifetime. (Courtesy of John Chuckman.)

USS Macon was an airship built for the US Navy. It was 20 feet shorter than the famous Hindenburg, which also made an appearance at the exposition. In terms of volume, the USS Macon was a larger ship. It flew over the fair but was lost nearly two years later in a storm off the coast of Big Sur, California. (Courtesy of John Chuckman.)

This interior view of the USS *Akron*, the *Macon*'s sister ship, affords a rare view of the rigid airships that served the Navy for scouting. The two "sisters" still hold the world record for helium-filled airships in size and volume. They were also designed to carry biplane parasite aircraft, thus acting as flying aircraft carriers. The USS *Akron* went down before the opening of the World's Fair. The US Congress formed a joint committee to Investigate dirigible disasters in 1933. Shown here is the pilot of the ship and a look at the exterior "hard-shelled" construction that was used in both sister dirigibles. (Both, courtesy of USNA/HMS.)

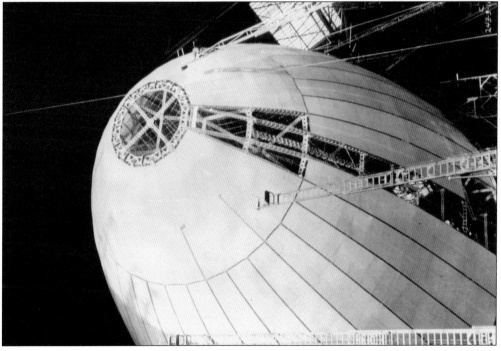

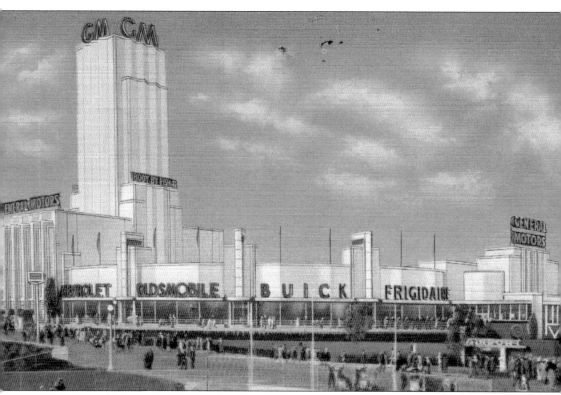

The General Motors building included a 177-foot tower that was brilliantly illuminated with colored lights. The central feature of the building was an assembly room as big as a city block. A thousand people at a time could witness a car being assembled; GM turned out a car every 20 minutes for interested visitors. In reality, a car could not really be built in 20 minutes; some steps were eliminated, because it was thought that most visitors would not stay to watch much longer. It took GM's assembly line more than one hour to make a car.

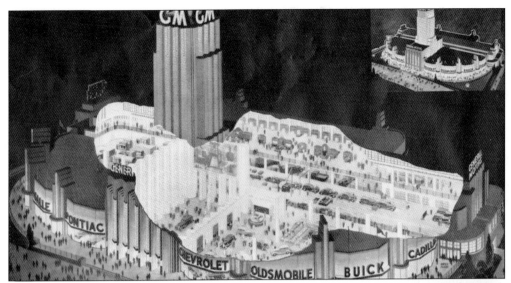

This cutaway view shows the Entry Salon, the Chevy Assembly Line, the Art and Color Exhibit, the Fisher Body Craftsman Guild, along with scientific exhibits by General Motors Research Laboratories. In the Entry Salon stood a statue by Carl Milles entitled *Precision*, illustrating that accuracy is the most important aspect of making automobiles. An unusual attraction was a giant Research Rainbow—a huge prism created by the scientists in the General Motors Research Laboratories—which produced an artificial rainbow of pure color tones. This illustrated the spectroscope they used to analyze steel that went into the cars. (Both, courtesy of Regina Ziemann.)

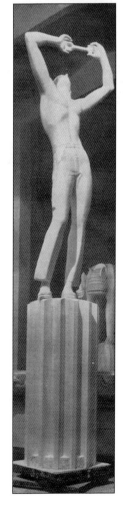

Oldsmobile straight eight and six touring sedans exemplified comfort and technology. The instrument panel, with large airplane-type dials, was illuminated, providing readings at a glance. Other amenities included comfortable seats, storage compartments, ventilation, and lots of room. Oldsmobile was a division of General Motors. (Courtesy of John Chuckman.)

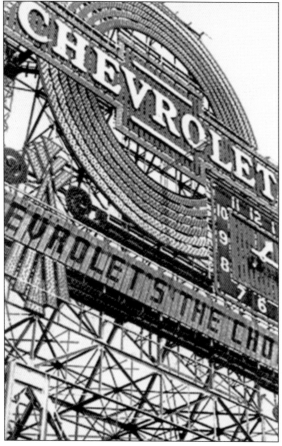

One of the most popular makes of automobiles was the Chevrolet, created by General Motors. Chevy production outpaced Ford from 1931 to 1933. The line offered a variety of styles, with prices ranging from $495 to $685. It was possible to order a Chevy from a dealer at home, go to the fair to see it being completed, and then drive it home. (Courtesy of John Chuckman.)

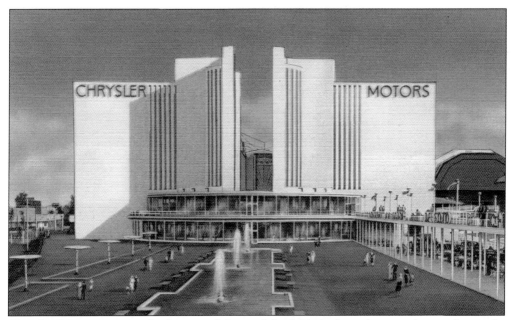

Chrysler Corporation was the largest exhibitor of the fair, which, with its pavilion and grounds, covered seven acres. It included sunken gardens, the Cyclorama, display areas, and a racetrack with banked turns for speed driving. Barney Oilfield and his crew performed six times a day on the track. Visitors could take a demonstration ride around the track with one of the drivers behind the wheel.

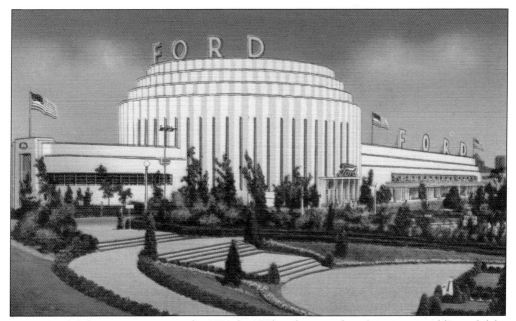

Henry Ford did not participate in the 1933 fair. When he saw what the positive publicity did for General Motors, he made sure that his building would be the most popular in 1934. The great rotunda, which emanated giant beams of light into the night sky, was only surpassed by the exhibits of his historical cars and his operations around the world.

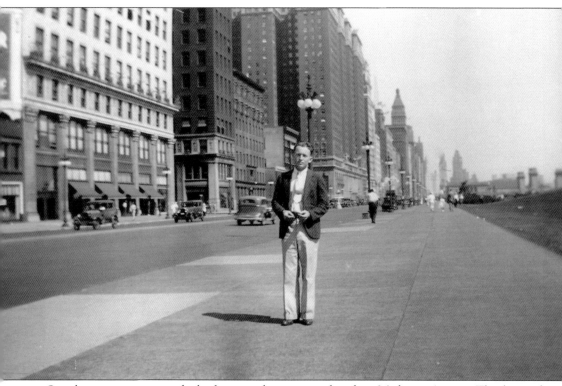

Seen here is a tourist outside the fairgrounds, camera in hand, on Michigan Avenue. The deserted street reminds one of Sally Rand's statement about the enticing draw of the Century of Progress Exposition, of which she was a great part. She said, "They planned the fair to bring business to Chicago, into the loop. But you could have fired a canon down State Street and hit nobody, because everybody was out at the fair." Brochures and pamphlets distributed there encouraged tourists to stay a few days to see the city and the surrounding forest preserves. One might visit Chinatown, the Gold Coast, the largest conservatory at Garfield Park, or the famous Midway that led to the University of Chicago. Everything was done to try and keep consumers spending their money in Chicago, and spend they did. But the lure of the fair was so exciting and the grounds so extensive, that there was little time for much else.

Three

SWEET HOME CHICAGO

" . . . so proud to be alive and coarse and strong and cunning . . . "
— Carl Sandburg

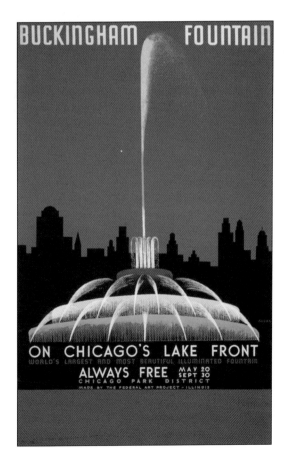

Buckingham fountain, situated in Grant Park, was the gem of the lakefront before and after the exposition. It symbolized the spirit of Chicago and was considered to be the "front door" of the city. As one steps through that door, one travels into the city to investigate the lives of those who, by choice or circumstance, called Chicago their home.

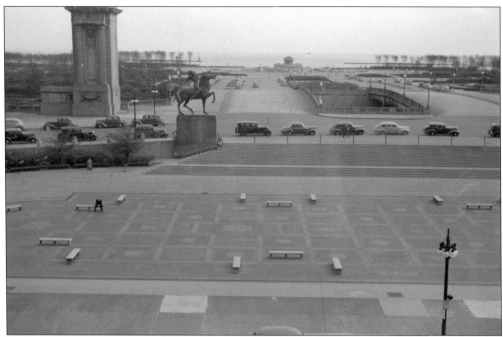

From Congress Park Plaza, (above) located at south Michigan Avenue and east Congress Parkway, this image looks toward Buckingham Fountain and into Grant Park; seen beyond is Lake Michigan. The equestrian sculpture to the left, entitled *The Spearman*, was created and placed in the plaza between 1926 and 1928. It was created by Ivan Mestrovic, a Croatian sculptor, and commissioned by the B.F. Ferguson Monument Fund to commemorated Native Americans. *The Spearman* (below) is mirrored by another sculpture called *The Bowman*, directly across from it on the other side of the stairs. Each sculpture was cast from eight tons of bronze and is six meters in height. Both sculptures are alike, as they have no visible weapons; they symbolize the struggle of Native Americans when the country was settled. (Above, photograph by John Vachon, courtesy of LC; below, photograph by Janet Duroc, courtesy of CC by SA.)

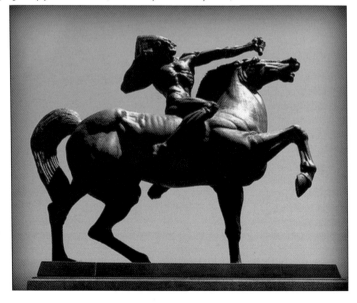

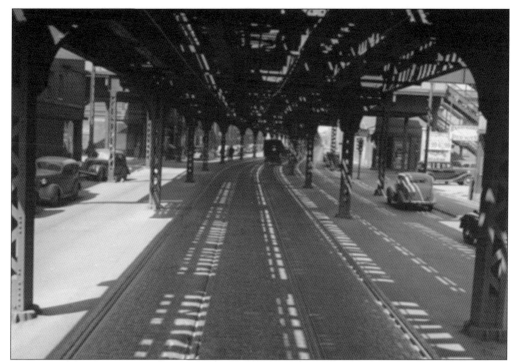

Travel around the city was made accessible to those who did not own a car. The "L," the elevated tracks of the Rapid Transit Network, completely surrounded the downtown commercial district, or the Loop, and connected the neighborhoods around the city. Here is a view of under the Lake Street L Station with streetcar tracks on the street. (Courtesy of IDOT.)

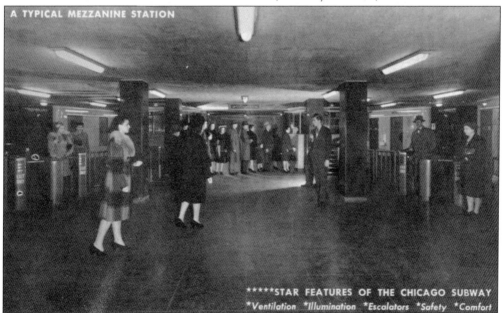

The Chicago Subway, also part of the Rapid Transit Network, was created to access most of the city. This mezzanine station promotes the idea that public transportation could be a comfortable experience. Streetcars and buses were also part of the system.

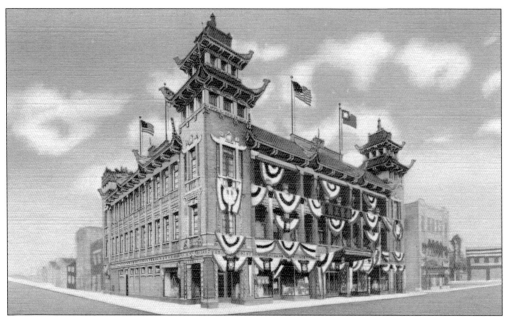

The beautiful On Leong Merchant's Association Building in Chinatown, at Cermak Road and Wentworth Avenue, opened its doors in 1928. It was designed using traditional Chinese architectural details with pagoda style towers, intricate terra cotta patterns—which were similar to the Chinese style tiles called *liu li*—and the guardian lions (Fu Dog) figures in the bas-relief. The designs were chosen to represent six Confucian virtues. The building needed to host a large number of people and to be used for a variety of activities. It included retail space, offices, a residential hotel, religious shrines, classrooms, and three meeting halls. The On Leong Tong made itself the center of the Chinese American Community, who relied on them for protection and justice that was not always available from their American-born neighbors. The On Leong Merchant's Association became a symbol of the organization's strength and leadership. (Below, photograph by Natalia Wilson, courtesy of CC by SA.)

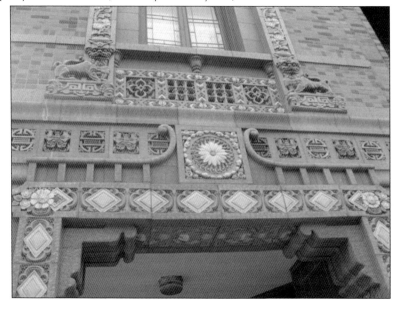

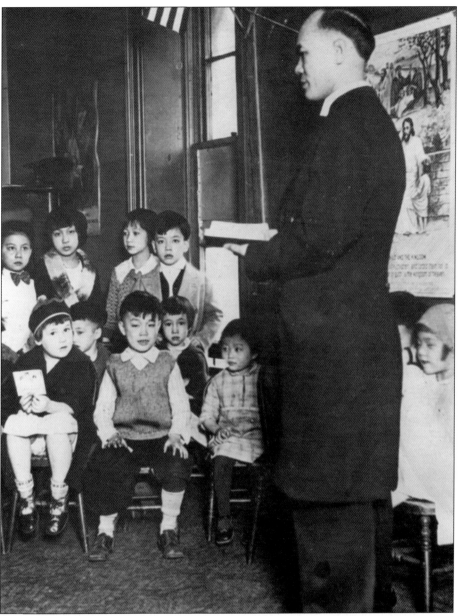

Chinese priest Henry Frank Chan is seen here teaching a group of children. Later, in January 1932, he was found dead in the basement of his temple, slain by blows of an axe. The slaying was very mysterious, and Chicago Police, who were called in to investigate, feared that it could trigger another Tong War. The Tongs were known for vice, gambling, murder, and prostitution. These secret societies had their own set of rules and punishments. Besides the On Leong Tong, there was the Hip Sing; both vied for territory and power. They began to lose money in 1930 due to the onset of the Depression. Chicago experienced a Tong War in which the On Leong Tong emerged as victor and took the best territories, including Wentworth Avenue. On Leong sold opium, the drug of choice for the people who indulged. The Hip Sing sold cocaine and heroin, which were not as popular in Chinatown. Most grievances were dealt with within the community, but murder, when discovered, fell into the jurisdiction of the city's judicial system.

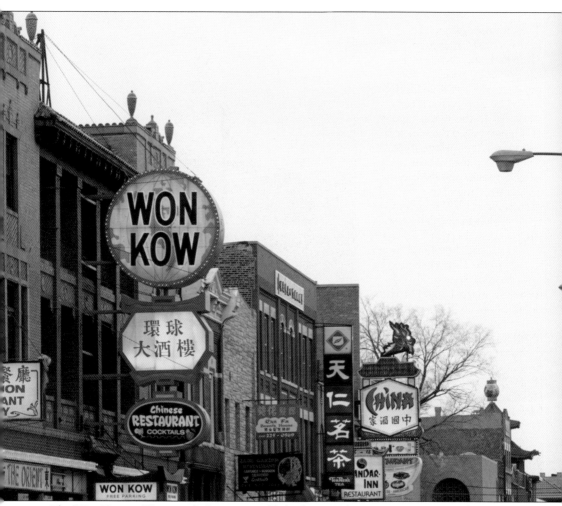

The Won Kow on Wentworth Avenue, established in 1928 by a restaurateur named only identified as Moy, is the oldest of Chinatown's restaurants, according to the Chinese-American Museum of Chicago. It was very popular with the Jewish community of the North and South Sides, who frequented it mostly on Wednesday nights. The delicious food was Won Kow's claim to fame. In 1930, sub gum chow mein cost $1.35; a waiter could earn $30 on the weekend in tips. Restaurants such as this provided essential benefits to the community. They were places to meet and celebrate the milestones of life, providing some happiness during the stressful times of the Depression. They also provided jobs for new immigrants and for the young who were trying to improve their situations. Successful business owners were models for other entrepreneurs, who fist learned the business by working for people like Moy. (Courtesy of Carol M. Highsmith Archives, LC, P&P DIV.)

The entrance gate to the University of Chicago in Hyde Park and the view of the university with the lily pond reflects a stylized Gothic look. The gate even includes gargoyles. In the 1930s, a group of scholars called the Chicago School studied the city itself. They created maps of the neighborhoods and studied the special structure of the city and occupancies of buildings and homes. They found that, with the exception of the Gold Coast, the poorest neighborhoods were nearest to the loop; this included Lincoln Park. Neighborhoods further from the Loop, like the South Shore and Rogers Park, were among the wealthiest. Most of the people who owned their own single-family homes were at the edge of the city. (Right, courtesy of Carol M. Highsmith Archives, LC, P&P DIV; below, courtesy of LC.)

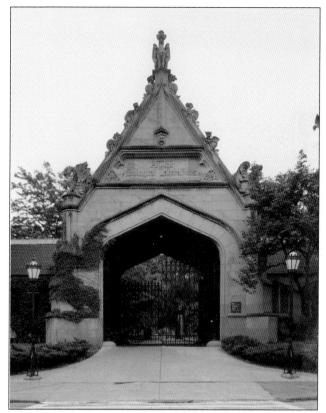

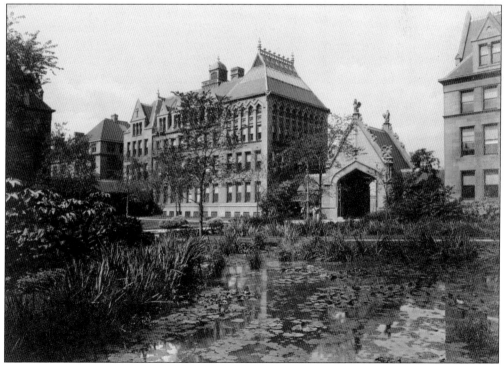

Amos Alonzo Stagg was the director of athletics and an associate professor at the University of Chicago from 1892 until 1935. He was a founding member of the Big 10 college conference. When he was 70, he was forced out of the university by its president, Robert Maynard Hutchins, whose reforms included eliminating varsity football. Stagg, after leaving the university, went on to coach for 20 more years.

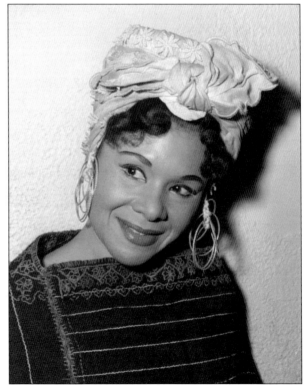

Katherine Dunham graduated from the University of Chicago with a B.A. in social anthropology in 1936. While in college, she taught dance in storefronts. Her student company, Ballet Negres, was the first black ballet troupe in the United States. The Dunham's Negro Dance Group was formed in 1937, performing African and African American choreography. Troupe members performed as guests with the ballet company of the Chicago Opera. (Courtesy of NYWT&S Collection, LC, P&P DIV.)

Studs Terkel studied law at the University of Chicago, graduating in the early 1930s. Instead of making his career in law, he began working in radio and joined the WPA's Federal Writers Program, which supported writers during the Great Depression. Terkel worked in radio documenting history, specifically oral history of the Depression, involving himself in the creation of radio programming. He recorded what life was like for persons living at the time. In an interview for the 20th-Century Project (Media Burn Archives), he was asked how he became involved in radio and the WPA. He said, "My life is an accretion of accidents. I had no intention of becoming an actor, disc jockey, or write books . . . I'm a Depression baby . . . and for the Depression people movies and radio were a great escape." Speaking about his involvement in the program, he continued, "This is very exciting stuff. There was a thrill to it, and even though there was a depression, you knew there was a light at the end of the tunnel because there was enlightenment up there, in Washington and elsewhere."

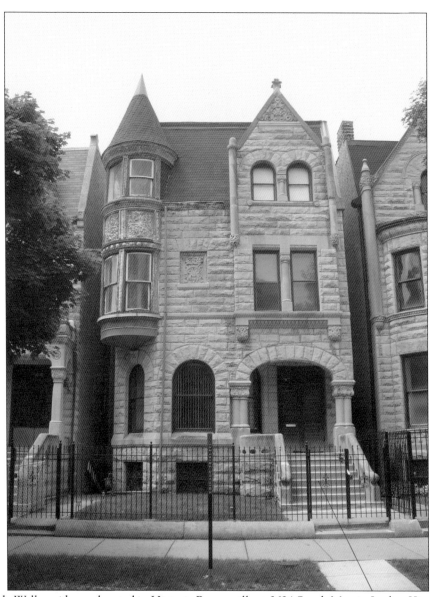

The Ida Wells residence, located in Historic Bronzeville at 3624 South Martin Luther King Drive (then Grand Boulevard), illustrates the economic symptoms of what was sometimes called the "Black Metropolis." Many African Americans migrated from the American South to Chicago in search of jobs. There was a great diversity of income and occupation within each neighborhood. Restricted housing practices and limited access to the downtown area forced African Americans to focus their efforts on building their own consumer-driven community. With encouragement from James Gentry of the *Chicago Defender,* the residents of Bronzeville recognized Jim Knight as the first mayor of Bronzeville. There were also social reforms aimed at the city and country at large. Ida Wells spent her life crusading for justice. She organized the NAACP, which worked with legislators in a longtime effort to eliminate lynching. Wells was the first black woman to be nominated for state legislature in 1930. She died in 1931; in 1939–1941, the Ida B. Wells Homes were constructed for African American families in Bronzeville. (Photograph by Antonio Vernon, courtesy of CC by SA.)

Young men in Bronzeville pose for Russell Lee, a photographer from the Farm Security Administration who documented the neighborhood on Easter Sunday, 1941. The photograph was taken on Grand Boulevard in front of the Savoy. One of the twins on the right is believed to be Dr. Samuel Hall, who died in 1987. He lived at 5023 South Indiana. (Courtesy of LC.)

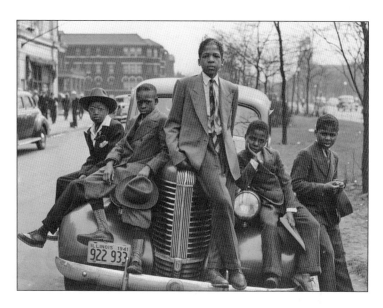

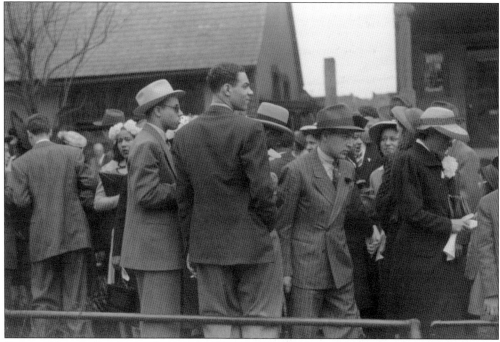

Fashionable people gather in front of the Episcopal church on Easter Sunday. Notice that the men are wearing double-breasted suits and fedoras—a highlight of men's fashion. In 1928, the church took on a new identity as an African American parish when white families left this neighborhood for Hyde Park or Kenwood. St. Edmund's Parish consisted of self-confident African Americans interested in family and tradition. (Photograph by Edwin Rosskam, courtesy of LC.)

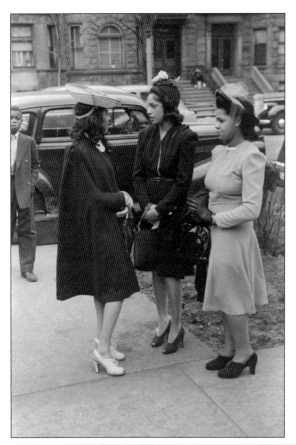

Shown here are young women in their Easter hats—a traditional accessory for the occasion—talking and waiting for the parade to begin at St. Edmund's Church, located at 5831 South Indiana Avenue. The church began in 1908 in a basement, and by 1940, it received a charter as a parish in the Diocese of Chicago. The clergy exiting the building, which was a simple structure of stucco and wood, led the procession. Eventually, St. Edmund's Church relocated to 61st Street and Michigan Avenue. (Both, photographs by Russell Lee, courtesy of LC.)

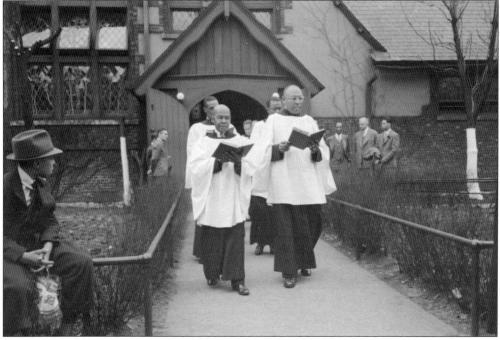

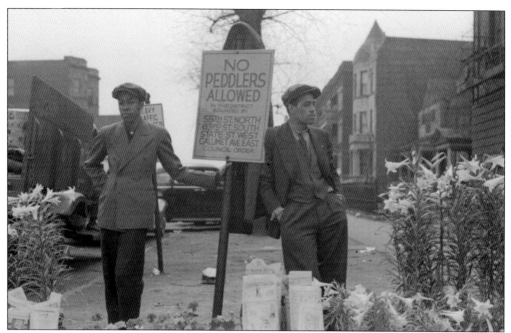

Not everybody could take the day off for Easter celebration; some seized an opportunity for economical purposes. These peddlers, selling Easter lilies on Garfield Boulevard, were trying to earn a living. Even though people were economically depressed, they did not dress like it, as seen by the suits the peddlers are wearing. (Photograph by Russell Lee, courtesy of LC.)

A group of girls have congregated outside the well-established Wendell Phillips High School (which is a Chicago landmark today), located at the intersection of Prairie and Pershing Avenues. The other high school in Bronzeville was DuSable, built by a Public Works Administration grant and opened in 1935 to accommodate the growing population of that segregated community. (Photograph by Edwin Rosskam, courtesy of LC.)

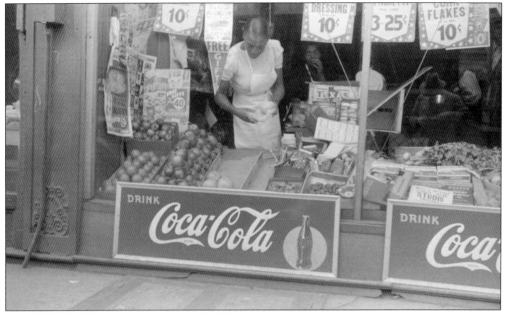

Many African American businesses flourished in the Depression. There were different levels of income woven throughout Bronzeville. Independent businessmen and women made livings in the local economy and became important parts of the social structure as well. Shown here are an independent grocery store and a barbershop, two small businesses the community needed and used regularly. Community businesses were often the focus of social interaction, where one could catch up on the news, business, and gossip of the day. According to the website *Urban Juncture*, large business flourished, such as *Ebony* magazine, Soft Sheen, the *Chicago Defender*, the Supreme Life Insurance Company, Binga Bank, and others. It was commerce that held the community together, because the residents were intent on improving the quality of their lives. (Both, photographs by Edwin Rosskam, courtesy of LC.)

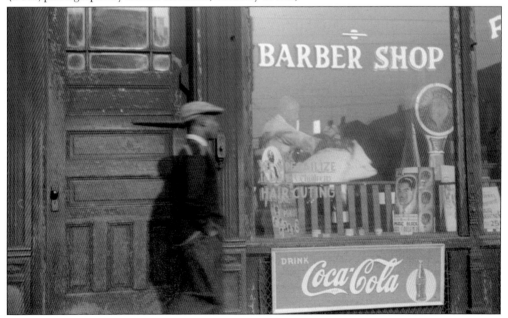

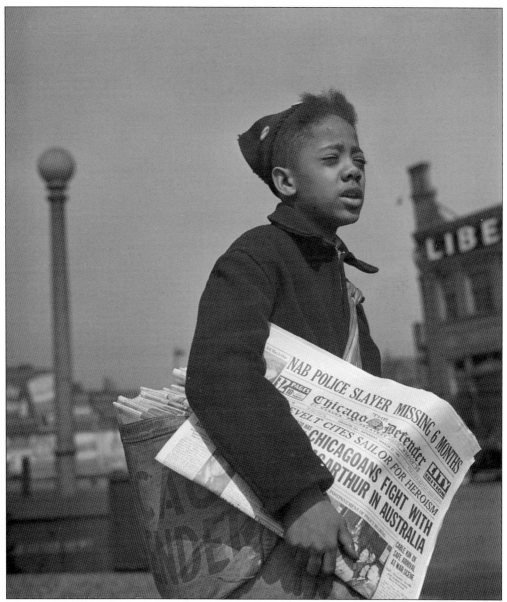

The *Chicago Defender* was the most celebrated newspaper in Bronzeville. Two-thirds of the *Defender*'s readers were from outside of Chicago. It promoted the great migration of African Americans to the North. Many people in the South depended on the train schedules, names of churches and organizations, and other information published there to help them find housing and employment in Bronzeville. The *Chicago Defender* became the national voice for the African American community. Writers such as Walter White and Langston Hughes served as columnists; Gwendolyn Brooks published her early poems there. Children who sold the paper on street corners were included in the Bud Billiken Club, sponsored by the paper. The club was meant to place a light on the youth of Bronzeville and to encourage them to raise their economical and social status through pride and achievements. Since 1929, on the second Saturday in August, the Bud Billiken Parade is held to promote the youth of the community. (Photograph by Jack Delano, courtesy of LC.)

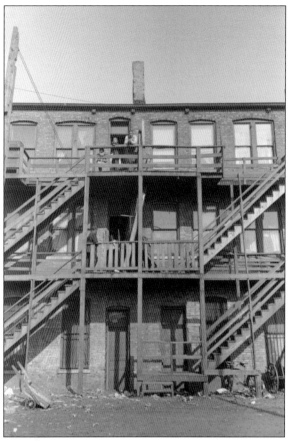

The *Electronic Encyclopedia of Chicago* explains the conversion of existing housing into smaller units. Buildings already in existence, like the one seen here with medium- to large-scale apartments, were divided, often by particleboard, into one- or two-room units by white and black landlords, allowing them to make great profits while exploiting the poor. The apartments had little space, a small cooking area, and inhibited sunlight; many families shared one bathroom. The writer Gwendolyn Brooks spent some years of her life in a kitchenette apartment, perhaps similar to the one pictured below. She is quoted saying, "I remember feeling bleak when I was taken to my honeymoon home, the kitchenette apartment in the Tyson on 43rd and South Park." Her poetry reflects her mood: "We are things of dry hours and the involuntary plan, grayed in, and gray." (Both, photographs by Russell Lee, courtesy of LC.)

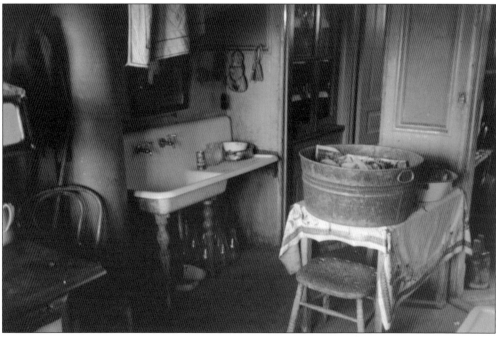

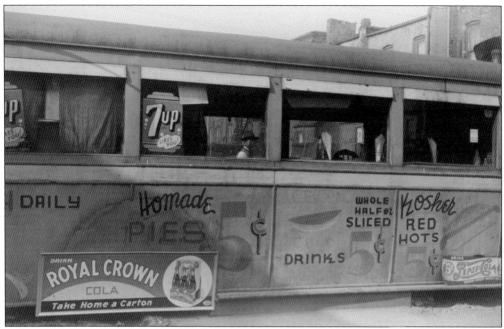

Pictured here is the conversion of an old bus into a restaurant by a resourceful entrepreneur. It seems to be permanently parked on an otherwise vacant lot in the poorest area of Bronzeville. Inside are tables set up with napkins in the water glasses, as if the owner was prepared for the lunch crowd. In the back of the bus, the man cooking is using an old stove to prepare some of the food that was on the menu, which included "Tasty Hamburgers," "Kosher Red Hots," "Homemade Pies," and "Ice Cold Watermelon." Most of the items cost customers 5¢, as did the drinks. Pepsi Cola, Royal Crown Cola, and 7 Up were featured with signage on the bus. Pictured below is an old Ford parked to the left and two men conversing on a somewhat cool and sunny morning. (Both, photographs by Edwin Rosskam, courtesy of LC.)

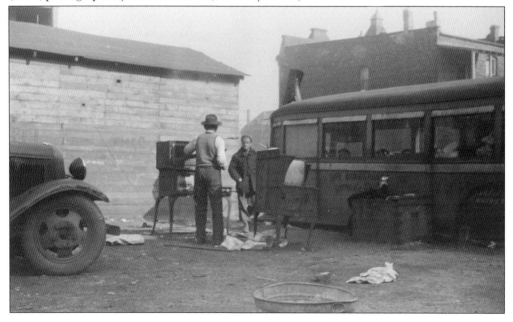

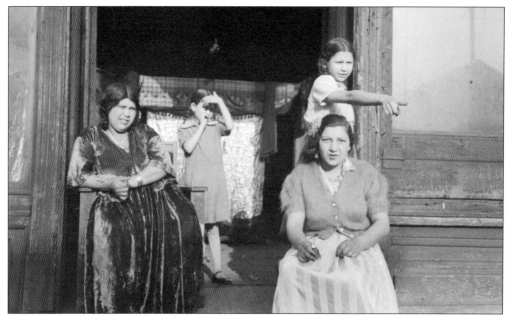

These two images of "Gypsies" living on Maxwell Street were taken by Russell Lee. In the first image, a girl seems to notice something in the neighborhood as Lee takes the shot. Before the second shot is taken, one woman leaves and the other laughingly covers her face. Calling themselves Rom or Roma—"those who roam about"— they had no interest in joining into community life. Their involvement was economical. According to Marlene Sway, author of *Familiar Strangers: Gypsy Life in America*, they were generally illiterate but musically talented. Men and boys were hired to play music from other immigrants' home countries at celebrations. The women read palms out of their houses or at fairs. They had no institutions but helped other Rom families through a well-established, private system. (Both, courtesy of LC.)

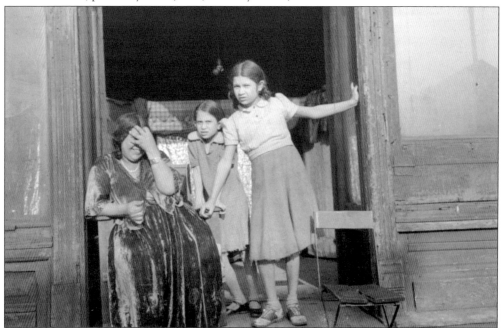

The Back of the Yards neighborhood gained notoriety in 1906 with the publication of Upton Sinclair's novel *The Jungle*. People living there were mostly employed in the Union Stockyards, which, for decades, was the central meatpacking industry in the United States. Pictured above is its historical gate. According to the Chicago Historical Society, the jobs there required little skill and did not demand much English. Poles, Germans, Slavs, and Bohemians worked on the assembly lines, in the slaughterhouse, and on the "killing floor." Women were employed in the packinghouses but earned less money than the men. Butchers were paid the best, as their jobs required skill. At the Chicago Stockyards, the three big packers were Philip Armour, Gustavus Swift, and Nelson Morris. To use Carl Sandburg's words, Chicago in the 1930s was still the "hog butcher for the world." (Above, courtesy of Carol M. Highsmith Archives, LC, P&P DIV; below, photograph by John Vachon, courtesy of LC.)

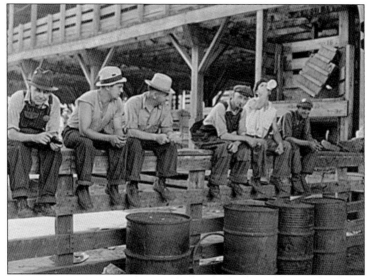

These houses on the 4800 block of South Elizabeth Street, in the Back of the Yards neighborhood, were divided into four flats each. They survived the cold winters with coal furnaces and radiators. Coal, delivered regularly, was stored in bins under the sidewalk. The Depression witnessed three of the ten worst snowstorms in Chicago: 19.2 inches on March 25–26, 1930; 16.2 inches on March 7–8, 1931; and 14.9 inches on January 30, 1939. According to Russell Lewis of the Chicago History Museum, the blizzard of 1930 topped off the city's snowiest winter with 58.2 inches of snow, closing schools and public transportation. Shoveling snow off streetcar tracks were 22,000 workers. City plows could usually push snow to one side of the street, as seen in these photographs. Car owners had to shovel out their own vehicles, as they still do today. (Both, courtesy of Stanley Shier.)

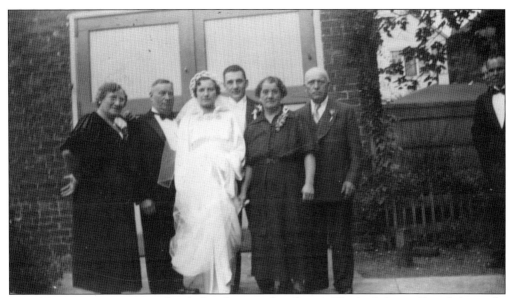

A wedding was commemorated with this photograph, taken on Elizabeth Street. From left to right are Angela and Stanislaw Plocharczyk, the bride's parents; Jean and Jim, the bride and groom; and Jim's parents, the Dryars. The ceremony was held at Saint John of God Catholic Church in Sherman Park on Racine Avenue. The area surrounding Elizabeth Street was basically a Catholic, Polish American neighborhood. (Courtesy of Stanley Shier.)

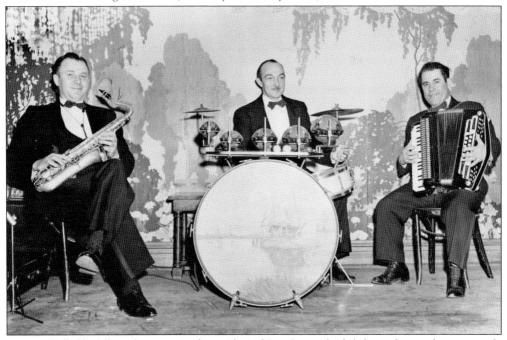

Joe Kazda (left), Albert (surname unknown), and Joe Grunt (right) formed a combo to provide supplemental income. The trio obtained gigs by word of mouth, playing at weddings, bars, and "smoky dives." In 1936, Kazda moved to 53rd Street and Damen Avenue, becoming a security guard for the Wilson Meat Packing Company at the Union Stockyards. However, he continued to moonlight as a musician for many more years. (Courtesy of George Kazda.)

Virginia Krieger (left) and Florence Gliwa (below) were best friends who grew up in Pilsen during the Depression. As a child, Krieger lived with her parents, five siblings, and her maternal grandmother in a flat at 2123 West 18th Place. Her mother, Pearl, often spoke of hard times the family endured. She said, "You know pork chops were ten cents a pound, neck bones were seven pounds for ten cents. I didn't have meat for two years." Later, the Krieger family moved to 1911 West 17th Street, where Gliwa and her family lived. The two girls quit high school at 16 for jobs to help out their families. Despite the hardships of the Depression, they found much happiness living in Pilsen. Both attended St. Adalbert's Church; there they were baptized, received their First Holy Communion, were confirmed, and later, married their husbands.

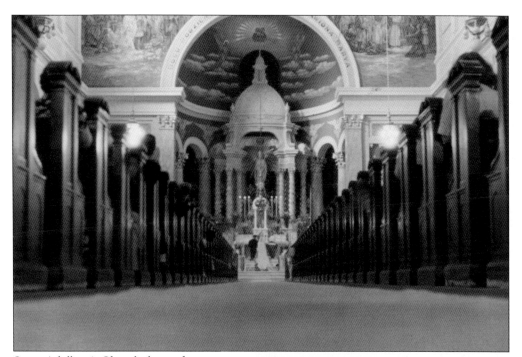

Saint Adalbert's Church, located at 1650 West 17th Street, was the spiritual and social center of the Pilsen community, which was mainly comprised of Polish Americans. It was modeled after St. Paul's Basilica in Rome. The twin bell towers of 185 feet ascended over the neighborhoods; the bells called the community to prayer several times a day. The interior view presented above gives a full view of the nave (body of the church), which is 195 feet long and 113 feet wide, and the apse (the place of the high altar). The high altar, made from 35 tons of Carrara marble, is surrounded by twisted columns, reminiscent of Bernini's Baldacchino in St. Peter's, Rome. The side altar, on the right, dedicated to the Virgin Mary, was often visited by brides during the wedding ceremony as a form of adoration and petition for blessings.

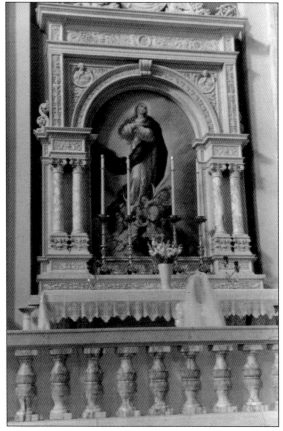

Patricia Ann Kurek (pictured right) was born in 1938. She, her father Stanley (left), and her maternal grandparents Gregory and Mary Gliwa (below) represent three generations of family living in Pilsen on 17th Street during the Depression. Gregory and Mary were born in Poland, but immigrated first to New York and then Chicago. They raised five children during the Depression; the older children worked to help the family. Their son Bruno, a teenager who had already quit school, joined the Civilian Conservation Corps, where he earned $30 a month. Gregory worked for Sears Roebuck, and Mary washed floors in the office buildings downtown. Eventually, around 1940, they bought the six-flat building in which they had been living at 1911 West 17th Street for $4,000. There, many of their children resided with their own families in the 1940s and 1950s.

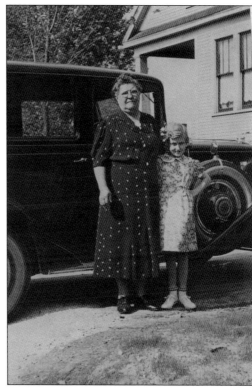

Gertie Doornbos (right) of Cicero, Illinois, came to visit her niece and namesake Gertie in Mount Greenwood, near 111th Street and St. Louis Avenue. The Doornbos owned a business and were able to afford a car during the Great Depression. The backyard, where young Gertie (below) is feeding the chickens, offers a view of Mount Greenwood as having open spaces with a rural-like setting, where one could plant gardens and raise poultry. Fourteen miles southwest of the Loop, it bordered such suburbs as Oak Lawn and Evergreen Park. Mount Greenwood was annexed into Chicago in 1927. The residents who voted for the annexation were hoping for a sewer system, paved streets, streetlights, and better schools. The Works Progress Administration finally began the improvements in 1936. (Both, courtesy of John and Shirley Rehling.)

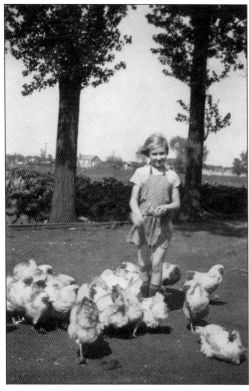

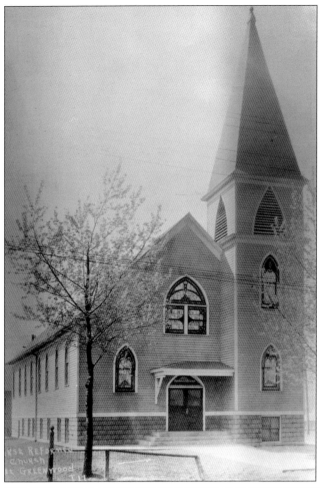

The first religious congregations established in Mount Greenwood were German Methodists and Dutch Reformed. Later, other immigrants moved into the area, including Irish, Welsh, English, Poles, Lithuanians, Swedes, Norwegians, and Danes. The area, bounded by cemeteries, one of which is pictured below, was once known as "the Seven Holy Tombs." A funeral service was and all-day affair; restaurants and taverns rose up to accommodate the mourners. Churches were essential to the needs of the community. On the left is the pristine First [Dutch] Reformed Church of Mount Greenwood at 3509 West 111th Street, in which families gathered to worship and socialize since its founding on July 30, 1913. Families from nearby communities, such as Blue Island, were included as members. (Left, courtesy of the Mount Greenwood Community Church; below, courtesy of John and Shirley Rehling.)

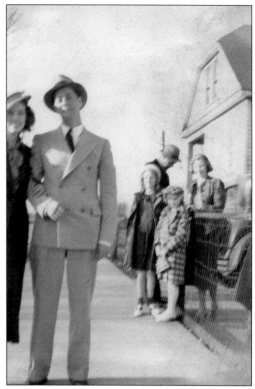

Across the street from the First Reformed Church sat the Rehling's family farm. Alfrieda and John Rehling, as well as other family members in the background, were dressed for Easter Sunday, 1938. Sixteen-year-old Cora Mooi (below) posed for a snapshot in her Easter suit, which was most likely purchased at the Sears on 63rd Street and Halsted Street. Shopping involved taking several streetcars to the larger stores quite some distance away; it was an all-day affair. Behind Cora are the open spaces of Mount Greenwood, where many farms survived throughout the Depression. Mount Greenwood was the home of the last surviving farm in the city, which closed in 1980. (Both, courtesy of John and Shirley Rehling.)

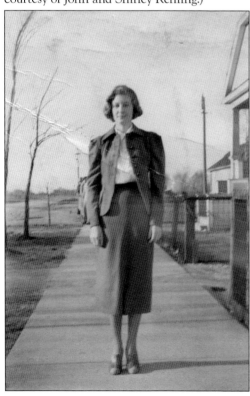

Richard and Jenny Weidenaar, Dutch truck farmers, are pictured here with their daughter. They earned their living by growing large quantities of vegetables, which they loaded onto their truck and took to South Water Street Market. The produce was sold to restaurants and grocery stores. The Weidenaars were members of the First Reformed Church of Mount Greenwood. (Courtesy of John and Shirley Rehling.)

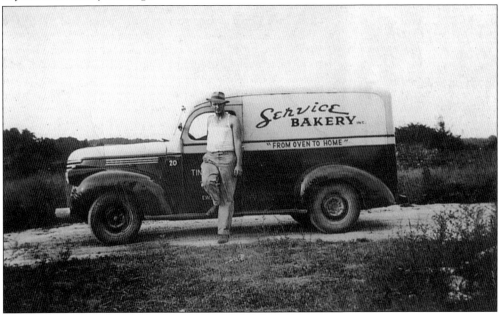

Elmer Haas, of Bohemian descent, worked at the Big Bear Golf Course (on 95th Street near 88th Avenue) doing grounds maintenance. The golf course was frequented by Capone's Chicago Outfit. After work, Hass could earn an extra dollar by washing cars. With his wages, he bought the bread truck pictured here, which he used to transport day-old bakery items he bought in Chicago and resold to farmers to feed their livestock.

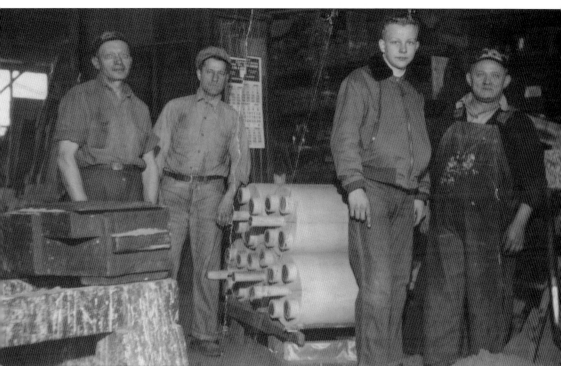

John Rehling (center left) got his first job in 1938 as a core maker at the Hansell-Elcock Foundry, located along the Chicago River. He stayed with the job throughout World War II. At first, the Stock Market Crash of 1929 had little effect on the ironworkers because iron was needed to complete jobs that were already in progress. By 1931, however, construction work slacked off, and as many as 50 percent of the workers lost their jobs; the wages were also cut in half. Because of the dangers of their work, many ironworkers lost their lives or became injured. Workers of diverse ethnic backgrounds were brought together as the jobs became unionized. In the thick of the Great Depression, the unions and reforms of the New Deal allowed ironworkers and steelworkers in the United States to make gains in pay and working conditions. Even so, Rehling could not afford to buy a house on his salary; he continued to live on the family farm at 101st Street and Pulaski Avenue throughout the war years. (Courtesy of John and Shirley Rehling.)

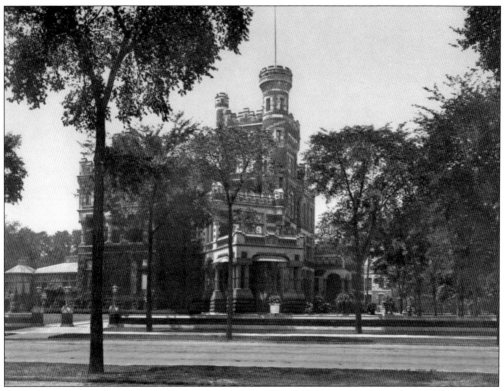

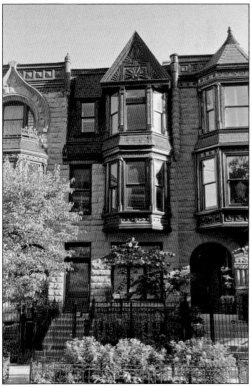

The Gold Coast is the only wealthy neighborhood edging the downtown area. It was mainly created by Porter Palmer, who built his mansion at 1350 North Lake Shore Drive to look like a German castle (above). In fact, he was the impetus that created Lake Shore Drive; he wanted a good street that would connect his home with the mainstream of Chicago. He built the largest private home in 1900; wealthy society followed to be next to the affluent Palmers. In 1930, his sons Honore and Potter Palmer Jr. sold the house for $3 million to Vincent Hugo Bendix. The Gold Coast consists of mostly high-rise apartments facing Lake Michigan. Inland are low-rise buildings, like the one pictured here on East Division Street. (Above, courtesy of LC; left, photograph by Jennifer D. Ames, courtesy of CC by SA.)

Three

ALL THAT JAZZ

"Come and show me another city with lifted head singing . . ."
— *Carl Sandburg*

The Savoy Ballroom, also known as Lady Savoy, opened on November 27, 1927, at 4733 South Parkway, in Bronzeville. It originally featured jazz but hosted activities like boxing, roller skating, basketball exhibitions, and banquets. From 1927 to 1940, it was open seven days a week. Most patrons were African American, but 15 percent of the jazz enthusiasts were Caucasian. (Courtesy of LC.)

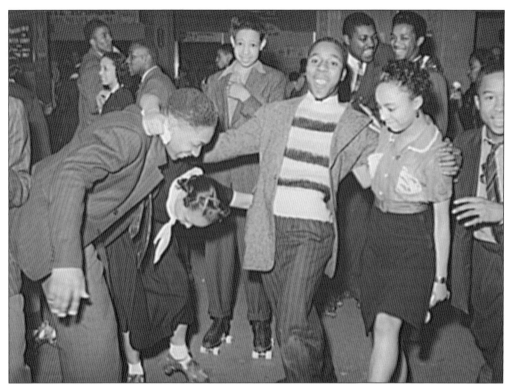

On Saturday nights, a popular activity in Bronzeville was to roller skate at the Savoy Rink. In general, roller skating was a form of recreation. Children had roller skates strapped onto their shoes as early as five years old, and usually skated on the sidewalks. The roller rink at the Savoy provided a large area for "fancy" skating; this included dancing on skates, which fit right into the big band era. In these photographs by Russell Lee, young people are seen enjoying the evening with friends and even swing dancing on skates. Instructors were available to teach the techniques needed to those who wanted to excel in the sport. (Both, courtesy of LC.)

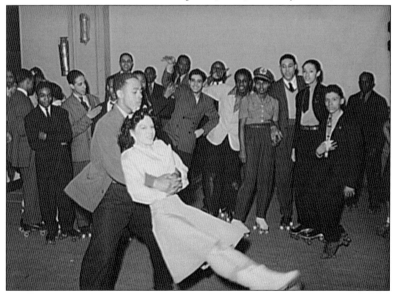

According to Prof. Jean Ferris, who wrote *America's Musical Landscape*, "Count (Bill) Basie defined jazz as 'music you can pat your foot to' . . . [he] became one of the most popular of all big band arrangers and leaders." Playing at the Savoy on numerous occasions, he brought with him the Kansas City style of jazz, "a pared-down, lighter, more relaxed music than jazz created in New Orleans or Chicago." He had a refined style of piano playing, choosing his notes meticulously. His band was noted for its rhythm section, which produced a perfectly balanced sound. It was considered the best swing band of the time. Seen here is the soundman setting up for a night of music and swing dancing at the Savoy. (Right, photograph by Russell Lee, courtesy of LC.)

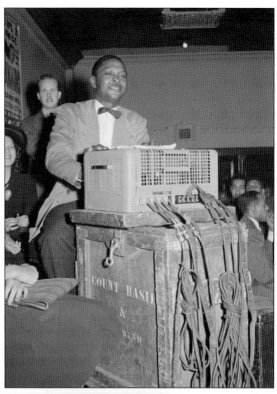

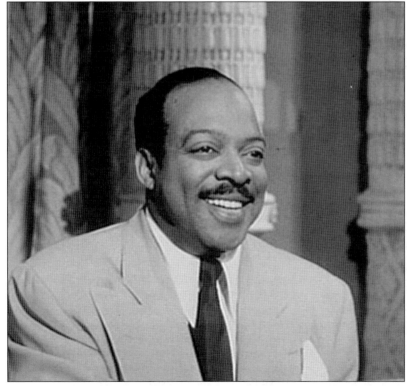

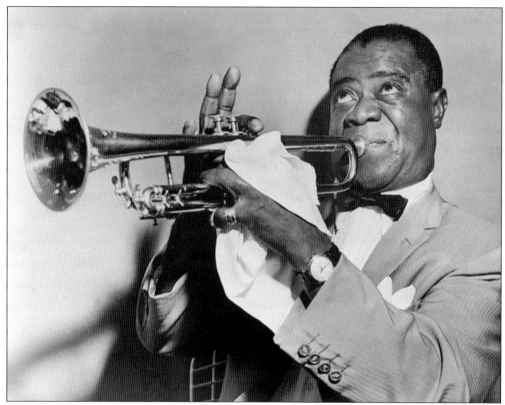

In the 1920s, Louis Armstrong left New Orleans to form his own band in Chicago, called the Hot Five (and later, the Hot Seven). According to Professor Ferris, while playing the trumpet, Armstrong "developed previously inconceivable virtuosic techniques for that instrument, producing pure, clarion tones that had never been heard before." While performing at the Savoy in the 1930s, "he personalized his performances as no one had before, taking the music and making it his own."

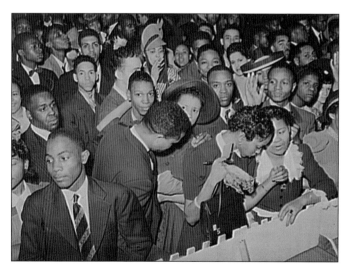

This crowd, dressed to the nines, jam-packed the Savoy. They came to hear the big bands that played swing, the popular music of the 1930s. Professor Ferris explains that swing "refers to a mood, a lilt, a magical effect that great jazz achieves and that sympathetic listeners recognize and respond to. When all element of a jazz performance come together and work, the music swings." (Photograph by Russell Lee, courtesy of LC.)

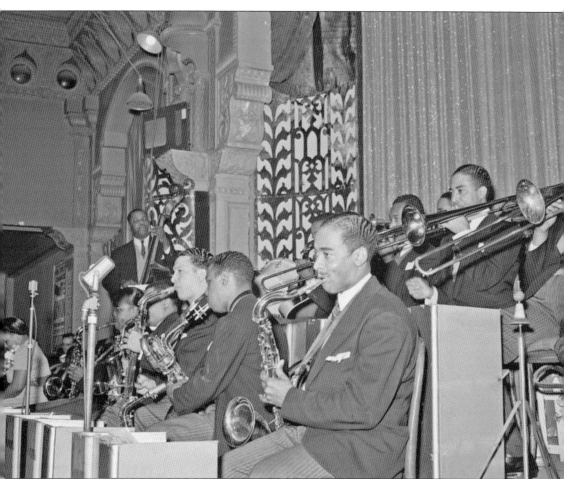

The earliest big bands had five or six players, but the standard soon became 12–18 musicians in three sections of instruments. The brass section, as seen in this photograph, consisted of trumpets and trombones (back row). The rhythm section included the bass (far left), but also guitar, piano, and drums. The woodwinds, or reeds, incorporated the saxophones (front row) and sometimes a clarinet. The big band sound improvised tunes that promoted swing dancing. Who could resist "Stompin' at the Savoy?" A popular swing dance in the 1930s was the Lindy Hop, named after Charles Lindberg. The Lindy Hop was improvisational, which worked well with the music. Later, it became known as the Jitterbug. (Photograph by Russell Lee, courtesy of LC.)

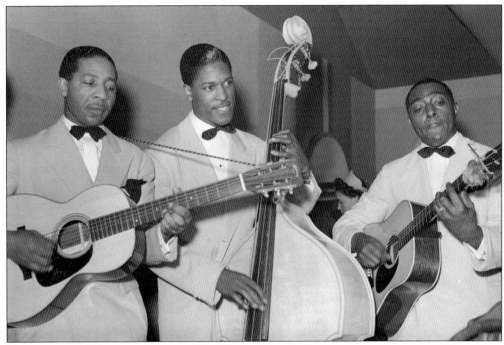

A small combo entertains in Bronzeville. On the left is rhythm guitarist, jazz singer and composer Lonnie Johnson, who, in 1941, recorded the tune "That's Love." Dan Dixon is to the right and possibly Andrew Harris on string bass. According to Anita Pravits's website, *Keep on Living,* Johnson formed the trio around 1938 and played at the Boulevard Lounge, Squyers Club, Flame Club, Plantation Club, the Gate and others in Chicago. Once a member of Louis Armstrong's Hot Five and a member of the Duke Ellington Orchestra, he recorded tunes for the Chicago labels Decca and Bluebird in the 1930s. (Both, photographs by Russell Lee, courtesy of LC.)

Singer and composer Frankie Laine (in the right image, front right) was born in Chicago's Near West Side in 1913. His remarkable voice allowed him to sing in halls without a microphone. At the age of 17, he performed at the Merry Garden Ballroom (below), located at Sheffield and Belmont Avenues, which held up to 5,000 people. There, while he attended Lane Technical School, he worked as a singer and ballroom instructor, and even a contestant in dance marathons. Originally a rhythm and blues performer, he entered the jazz scene and opened up to a variety of genres including gospel, rock and roll, and popular standards as his career expanded. His style and popularity earned him the moniker of "Mr. Rhythm." (Right, photograph by William P. Gottlieb, courtesy of LC; below, courtesy of the *Daily News* archives.)

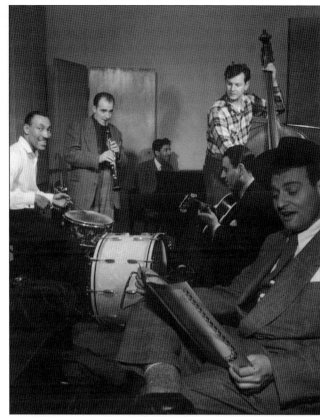

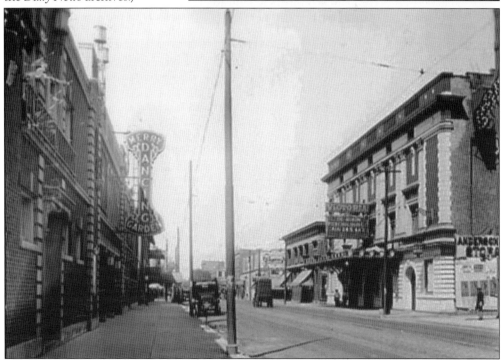

Gene Krupa, whose father was an immigrant from Poland, was born in Chicago. In 1927, he broke out into the Chicago jazz scene playing drums for Thelma Terry and Her Playboys at the Golden Pumpkin, located at 3800 West Madison Street, advertised as "the world's largest Chinese café." Thelma Terry was the first woman to lead a notable male jazz orchestra. In the day, women bandleaders usually were associated with female orchestras. Krupa became known as a renowned drummer, composer, and bandleader. His genre included jazz, swing, Dixieland, and big band. During the Depression, he played with the Benny Goodman Orchestra and the Benny Goodman Trio at the Congress Plaza Hotel. Krupa was known as the "King of Swing" until he relinquished the title to Goodman. (Photograph by William P. Gottlieb, courtesy of LC.)

In the mid-1930s, Anita O'Day was a jazz singer at Sam Beers Three Deuces, 222 North State Street, in the downstairs room called the Off Beat Club. O'Day was a sultry vocalist of bebop and improvisational jazz. Born Anita Belle Colton in Chicago, she started out in Uptown as a chorus girl. Eventually, she changed her surname to O'Day, which is pig Latin for "dough" (a slang term for money). Gene Krupa hired her for his orchestra in 1941. Her first million-selling record, "Let Me off Uptown," was sung with Roy Elbridge, an African American jazz vocalist and trumpeter. This was a groundbreaking duet, since black and white entertainers did not usually perform together; in fact, it was taboo. However, the steamy record was big hit. Adam Bernstein of the *Washington Post* wrote her obituary in 2006 when she died at the age of 87. He said her "breathy voice and witty improvisation made her the most dazzling jazz singer of the last century and whose sex appeal and drug addiction earned her the nickname 'The Jezebel of Jazz.'"

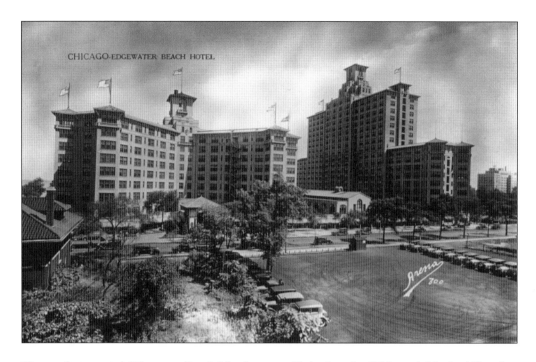

The prodigious, pink Edgewater Beach Hotel was established on the 5300 north block of Sheridan Road, near Foster Avenue, right off the shores of Lake Michigan. Its guests enjoyed 1,200 feet of private beach. If one wanted to dance under the stars, one would go to the Edgewater. It also included a ballroom where proms, college dances, and weddings could be booked. During the big band era of the Depression, it became a venue for popular bandleaders like Glenn Miller and Tommy Dorsey. Because the hotel had its own radio station, WEBH Chicago, remote transmissions made it possible for people at home to enjoy live performances from the Edgewater by air.

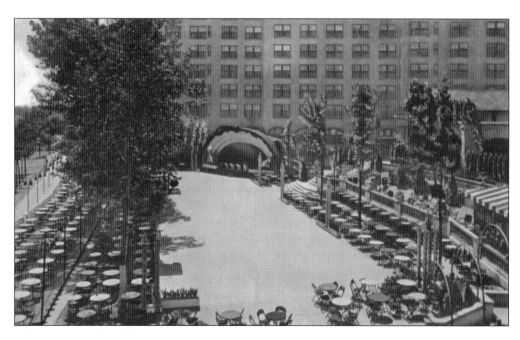

Thomas Francis "Tommy" Dorsey was known as the "Sentimental Gentleman of Swing" because of his smooth trombone playing. Frank Sinatra was quoted to say, "My greatest teacher was . . . the way Tommy Dorsey breathed and phrased on the trombone." He was also a trumpeter, composer, and bandleader. His own highly popular and successful orchestra was a big draw in Chicago at the Edgewater, the Aragon, and the Palmer House.

The Glenn Miller Orchestra was probably the most easy to recognize. In 1940, he recorded 45 best-selling tunes. Ferris wrote, "He developed a distinctive sound—a clarinet supported by four saxophones—rich, sensuous, and nearly irresistible." In this publicity photograph, he displays his trombone. He played at the Edgewater Beach Hotel, the Aragon Ballroom, and other venues around Chicago.

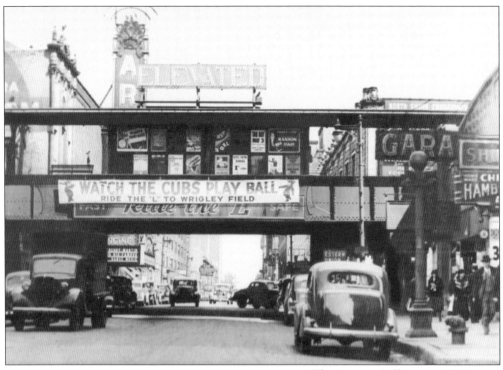

The Aragon Ballroom at 1106 West Lawrence Avenue in Uptown opened in 1926 with a capacity of 4,500 people. Its close proximity to the "L" (seen above) provided easy access to the venue. The official website, *Aragon Entertainment*, boasts that "playing at the Aragon was regarded as having 'big time' status." Benny Goodman, Tommy Dorsey, and Glen Miller were some of the big band acts that were booked there; the music was broadcasted live by WGN radio. According to the website, secret tunnels leading from the nearby Green Mill Lounge to the basement of the Aragon allowed Al Capone secret access to the building. From his private booth in the southwest balcony, he could enjoy the entertainment but also have access to a fire escape for a quick departure. (Above, courtesy of John Chuckman; left, photograph by H. Callas, courtesy of CC by SA.)

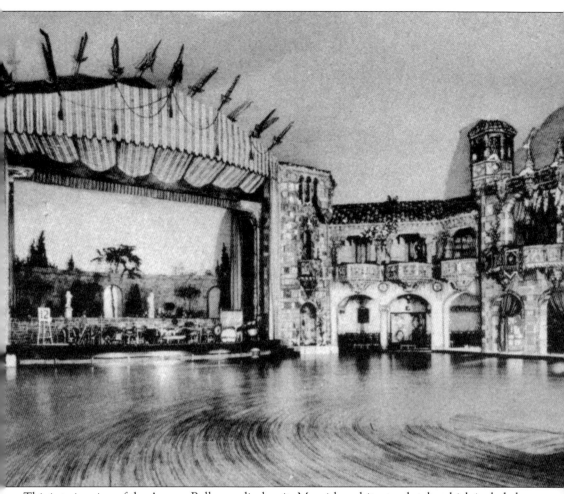

This interior view of the Aragon Ballroom displays its Moorish architectural style, which included balconies, chandeliers, mosaic tiles, and ornate columns. It was named after a province in Spain and meant to be a representation of a Spanish courtyard. The octagonal ballroom floor was designed to accommodate thousands of people who danced under a ceiling simulated to look like the night sky. It was advertised as the "Ballroom of a Thousand Delights." One of the delights of the ballroom was the opportunity for singles to meet in an upscale setting. Men were required to wear jackets and ties; women wore semiformal dresses. No close dancing or jitterbug dancing was allowed.

The Loop welcomed its first movie palace, the Chicago Theater, in 1921. Opulent and luxurious, it was called "the Wonder Theatre of the World." Located at 175 North State Street with a capacity to seat 3,600 people, it cost $4 million to construct. The building's facade contains a 60-foot-wide and six-story-tall arch reminiscent of the Arc de Triomphe in Paris. It encompasses a circular Tiffany stained-glass window. The horizontal sign "Chicago" on the State Street marquee contains the city's municipal badge in the form of a "Y," which is meant to represent the fork in the Chicago River at Wolf Pointe. The vertical sign is iconic of State Street and Chicago. The theater, a Chicago Landmark, was placed in the National Register of Historic Places in 1979. (Above, photograph by John Vachon; below, courtesy of HABS, LC.)

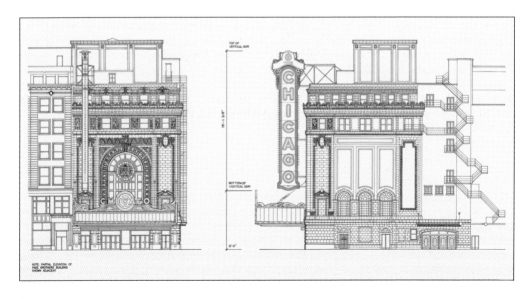

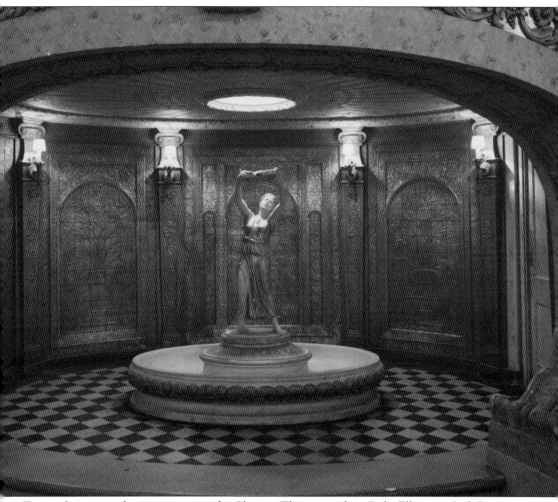

Top performers made appearances at the Chicago Theatre, such as Duke Ellington, Jack Benny, Benny Goodman, and others. In 1938, Roland Reagan became engaged to Jane Wyman there. However, its biggest draw in the 1930s was live jazz. Seen here is the interior of the theater with its French Baroque style. The grand lobby of the theater, five stories high, was inspired by the Royal Chapel of the Versailles Palace in France. The Baroque-style sculpture pictured here was created by Michelangelo Studios of Chicago. The Balaban and Katz Theatre Corporation, along with the architectural firm Rapp and Rapp, were the visionaries who brought this movie palace to Chicago. (Courtesy of Carol M. Highsmith Archives, LC, P&P DIV.)

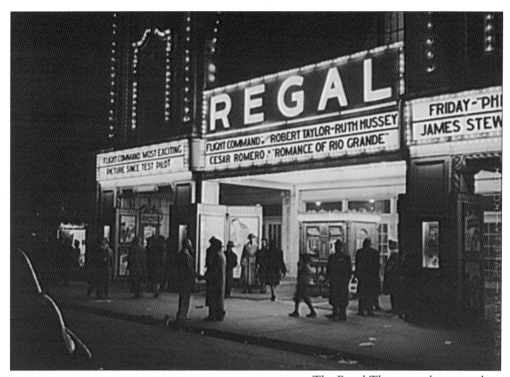

The Regal Theater—also created by the Balaban and Katz Theatre Corporation—at 4710 South Parkway in Bronzeville, featured motion pictures and live stage shows. It opened in 1928. The Regal hired African Americans for all aspects: management, ushers, house musicians, cashiers, and attendants, making it a valuable economic asset to the community. (Photograph by Russell Lee, courtesy of LC.)

Duke Ellington and his touring jazz band often played at the Regal Theater in Bronzeville. In 1930, he composed his famous song "Mood Indigo," which was "slow and bluesy" according to Ferris. He was recognized as a serious composer and was noted for the hot style of jazz he played at the popular Cotton Club in Harlem, New York, where he initially formed his orchestra.

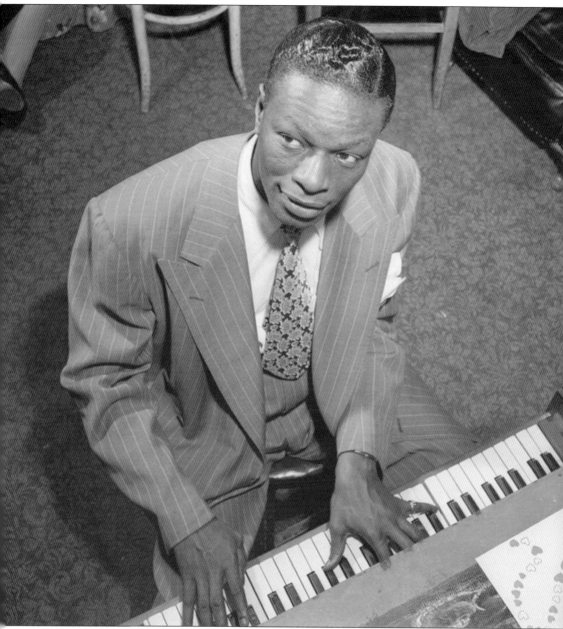

Nathaniel Adams Coles, better known as Nat "King" Cole, was born in Montgomery, Alabama; when he was about four years old, his family moved to Chicago. Considered a Bronzeville native, he began playing at the Regal's Amateur Night. He would sneak out of his house in the evenings to listen to music coming from the clubs; standing in the alley or by the stage door, he could hear Louis Armstrong, Earl Hines, Jimmy Noone, and others performing. Although he started out in his early life studying the piano and playing organ at his father's Baptist church, he was inspired by jazz and especially Earl Hines. At the age of 15, he dropped out of school to pursue a career in music. In an interview with *Voice of America*, he said, "I started out to become a jazz pianist; in the meantime I started singing and I sang the way I felt and that's just the way it came out." (Photograph by William P. Gottlieb, courtesy of LC.)

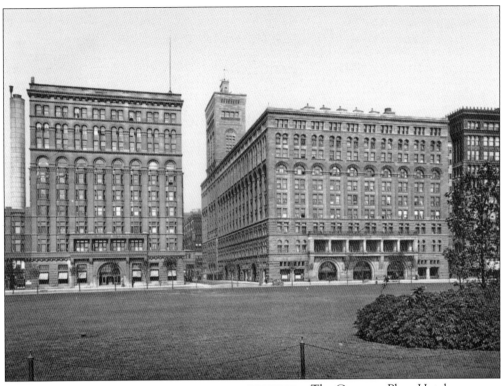

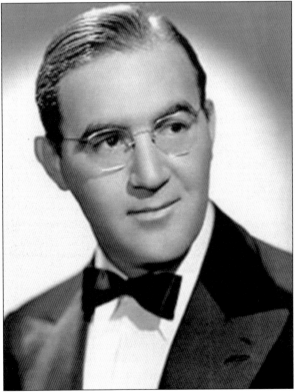

The Congress Plaza Hotel on Michigan Avenue near Grant Park became the 1935–1936 headquarters for an NBC radio show featuring Benny Goodman. Playing in the Joseph Urban Room, the band featured Gene Krupa on drums, Jess Stacy on piano, and Helen Ward as the vocalist. The live broadcasts featured tunes such as "If I Could Be With You," "When Buddha Smiles," "It's Been So Long," and others. The band played at the Congress Hotel for seven months but also cut records in Chicago for RCA Victor's Blue Bird label like *Stompin' at the Savoy*, and *Goody Goody*. Goodman, Krupa, and Teddy Wilson also formed a trio, which played "Rhythm Club" concerts held at the Congress Hotel. It was at that time that Krupa gave Goodman the moniker "King of Swing."

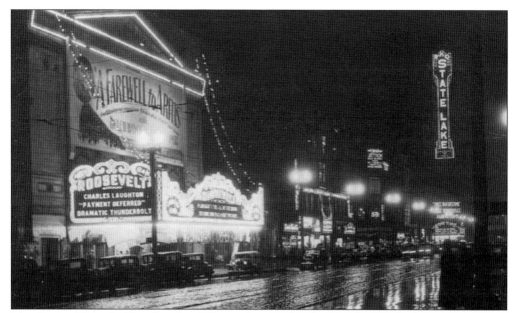

Max Grinnel from the *Encyclopedia of Chicago* denotes that the Loop had the highest concentration of movie theaters in Chicago by the late 1930s. He states that "Chicago helped launch the movie industry in the United States in the early 1900's." The Roosevelt Theater was designated only for films. At the State-Lake Theater, a ticket could buy a stage show as well as a movie. (Courtesy of John Chuckman.)

The Town Casino "Show Bar," located at 6 North Clark Street, finds friends, from left to right, Irene (surname unknown), Virginia Krieger, and Ruth (surname unknown) enjoying the nightlife in the Loop. Nightclubs and movie theaters made the Loop a hub for the entertainment industry, which provided employment for Chicagoans. This image, taken at the end of the Depression, displays the self-confidence of women who were now able to find opportunities for work and leisure outside the home.

The Great Depression drove the price of radios from about $139 in 1929 to $47 in 1933. By 1933, approximately 60 percent of American households owned a radio. President Roosevelt used his "fireside chats" to inspire and motivate the country during the hard times. Main sources of relief to the beleaguered populace were the musical broadcasts and the comedy shows. Programs such as *Fibber McGee and Molly* and *Amos 'n' Andy* originated in Chicago. On the left, a young girl in her living room enjoys some programs. Remotes from around Chicago allowed the listeners to visit places they could not physically be—like in the kitchen of the Sherman Hotel, where chef Tom Magliano describes one of his newest dishes (seen below). The radio provided a lifeline to many, connecting them to the world at large. (Left, courtesy of FDR; below, courtesy of LC.)

Five

OPEN TO THE PUBLIC

" . . . *here is a tall bold slugger set vivid against the little soft cities* . . ."
— *Carl Sandburg*

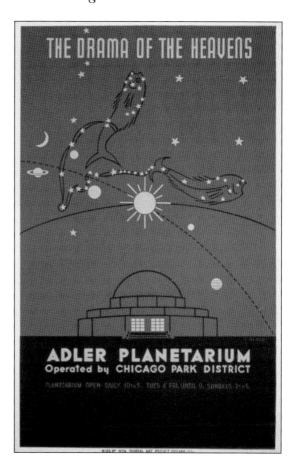

A brainchild of Max Adler, a retired Chicago executive, the Adler was America's first modern planetarium. In 1930, it was built at 1300 South Lake Shore Drive in the Art Deco style. Its most dramatic event was held in 1933, when light from the star Arcturus was converted into electrical current, sent to the Alder, and used to light the opening of the World's Fair. (Courtesy of LC.)

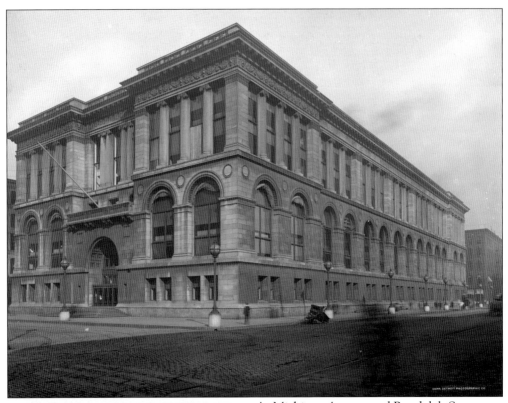

At Michigan Avenue and Randolph Street, one could find the main branch of the Chicago Public Library. As depicted in this photograph, it took up an entire city block. Moreover, its branch system placed neighborhood libraries throughout Chicago, making knowledge accessible and within walking distance to the public during the Depression. In 1932, the George Cleveland Hall was the first branch created in Bronzeville; it was headed by Vivian G. Harsh (pictured left). A well-educated woman, she was the first African American to head a branch of the Chicago Public Library. She created cultural programs as well as collections of Afro-American history and literature, greatly contributing to the Chicago Black Renaissance. Authors such as Langston Hughes and Gwendolyn Brooks supported the library, which became a meeting place for African American thinkers and activists during and after the Depression. (Above, courtesy of LC; left, courtesy of the Vivian G. Harsh Research Collection of Afro-American History and Literature, George Cleveland Hall Branch Library Archives, Chicago Public Library.)

The Art Institute of Chicago, located at Michigan Avenue and Adams Street, offered free entry to its exhibits during the Depression. Its extensive collection of artwork, sometimes dependent on donations and patrons, provided the population with a cultural tie to the world. According to *ARTstor*, a digital archive created by the Mellon Foundation, "During the depths of the Great Depression, the museum received the single most comprehensive gift of art in its history, the bequest of Martin A. Ryerson. This donation contained masterpieces ranging from American and European paintings dating to the 15th century to textiles, prints and drawings, Asian art, and European decorative arts." This institute, created as a museum as well as a school for fine arts, was always a draw for visitors as well. (Both, photographs by John Vachon, courtesy of LC.)

A man sporting a stylish fedora is seen window-shopping at Howard Clothes in the Loop. The 1930s ushered in the ready-to-wear fashion age in an effort to make clothing affordable. Also, manufacturers used less expensive materials, rayon blends, and zippers to cut down the cost of fashion. The suits in this window range from $22.50 for the double-breasted suit to $17.50 for the single-breasted style. (Photograph by John Vachon, courtesy of LC.)

Two Catholic nuns have just arrived in the Loop by the "L." It seems they have decided to see *The Human Beast* by Emile Zola, a tense psychological thriller released in 1938. This French film was directed by Jean Renoir and starred Jean Gabin, Julien Carette, and Simone Simon. It was screened at the air-conditioned Fine Arts Building, located at 410 South Michigan Avenue. (Photograph by John Vachon, courtesy of LC.)

The city of Chicago claimed to be the largest railroad center in the world, accommodating passenger as well as freight trains. Thirty-eight railroads terminated in the city, but a significant number of trains were reduced during the Depression. The interior of the Union Station, created in the Beaux Art style, include fluted columns, marble floors, and a vaulted skylight. The Great Hall, seen here, provided a vast area for passengers who waited for or departed from trains. Since this area was always open to the public, many people could just come in and rest for a while. The exterior view of Union Station shows locomotives pulling out of the south side of the building; 10 tracks headed south and 10 tracks went north from 225 South Canal Street. (Above, photograph by John Vachon, courtesy of LC; right, photograph by Jack Delano, courtesy of LC.)

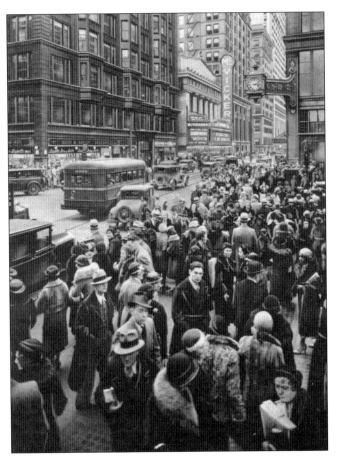

The intersection at State and Madison Streets, the busiest corner in Chicago, became the center of activity in the Loop and marked the base point for the Chicago address system. The iconic Marshall Field clock can be seen above the crowd. The popular store occupied almost a square city block, stood 13 stories high, and had three basement floors. It was considered the largest high-grade mercantile establishment in the world. The firm employed between 4,000 and 5,000 people, depending on the season. More than a store, it had restaurants, lounges, smoking rooms, and the first escalator in a department store. A magical aspect of Marshall Field was the window display. Each window was designed as if it were a scene from a play, enticing the passersby. For many, window-shopping became a pastime during the Depression.

MARSHALL FIELD & CO., CHICAGO

The Michigan Avenue Bridge (today called the DuSable Bridge) allowed the shopping district to shift from the Loop to "the magnificent mile" (a term coined in the 1940s) of North Michigan Avenue, spanning the Chicago River. It was the first double-decked bascule bridge in the world. DuSable's trading post was once located at the north side of the bridge; Fort Dearborn was on its south side. (Photograph by John Vachon, courtesy of LC.)

This is a 1970 view of the Outer Drive Bridge, which was completed in 1937. Crossing the Chicago River, it connects the south side of the city to its north side. It still is the largest bascule bridge in the world. During the Great Depression, the Public Works Administration (PWA) provided money to construct it in an effort to stimulate work and ease traffic flow on Michigan Avenue. (Courtesy of LC.)

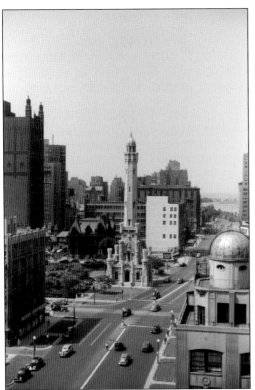

An important historical attraction was the Chicago water tower. Located at 806 North Michigan Avenue, it was the center of "the magnificent mile." Because it was one of the few buildings to survive the Great Chicago Fire, it symbolized Chicago's tenacity. Shown in this image is the sharp distinction between the water tower and the surrounding buildings, which had, through progress, replaced the Gothic-like style with a sleeker modern look. (Photograph by John Vachon, courtesy of LC.)

Metropolitan Chicago, by 1935, numbered approximately 1,800 churches, synagogues, and temples. Temple Shalom, located at 3480 North Lake Shore Drive, was one of the oldest synagogues in Chicago, established in 1867 as a Reform Jewish congregation. The octagonal, Byzantine Revival–style building was completed in 1928; its architects were Charles Hodgson and Charles A. Coolidge. In 1933, Chicago's Jewish population was 270,000, nine percent of the city's total population. (Photograph by Gerald Farinas, courtesy of CC by SA.)

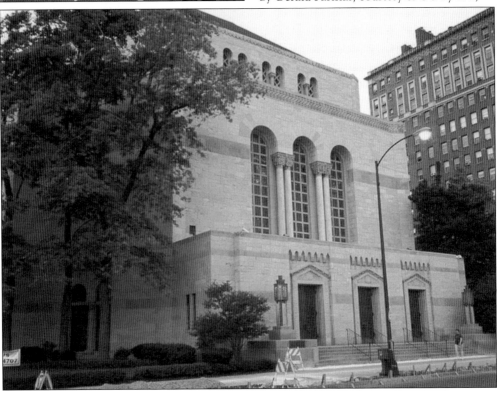

The Museum of Science and Industry, founded by Julius Rosenwald, is located in Jackson Park on the city's south side. Often recognized as one of the most beautiful buildings in the world, it was compared to the Parthenon. Open every day of the year with no admission charge, visitors could enjoy hundreds of exhibits depicting the progress of modern science and engineering, including a full-sized bituminous coal mine.

Created by Marshall Field, the Field Museum of Natural History was one of the first four scientific museums of the world. In 1934, it represented a value of $50 million. The central collection of this museum consisted of the valuable material from the World's Fair of 1893. It continually accumulated exhibitions throughout the years. Its five main departments were anthropology, botany, geology, zoology, and the N.W. Harris Public School Extension.

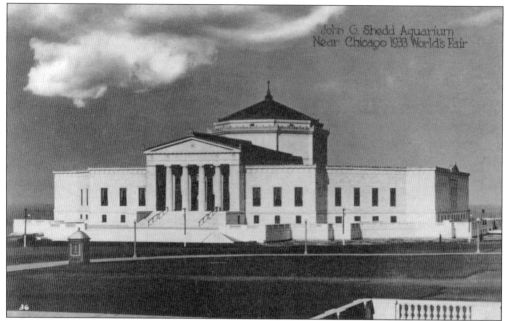

The Shedd Aquarium, situated on Chicago's lakefront, was a gift of John G. Shedd, chairman of the board of Marshall Field and Company. Constructed from Georgia marble, its octagonal shape held 32 permanent wall tanks in 1934. The total tank capacity was 500,000 gallons of water, providing an excellent view of the aquarium's comprehensive collection of live aquatic animals. Its director was Walter H. Chute.

The Lincoln Park Conservatory, located at 2391 North Stockton Drive near the shore of Lake Michigan, gave visitors a tropical experience with free admission. Ancient ferns, exotic plants, and flowers from around the world were grown there for use in the other Chicago parks. Once called Lake Park, it was renamed after Abraham Lincoln's assassination in his honor. In 1934, it was expanded north to Foster Avenue.

In 1934, approximately 22 independent park commissions were consolidated into the Chicago Park District, with over 100 parks and playgrounds. Shown here are the ferns and the lily pond in the Garfield Park conservatory on the northwest side of the city. Flower shows were held here several times each year and 4,700 species of flowers were displayed. The "gold dome," once administrative offices, became a field house in 1934. In the city's publicity souvenir booklet *Chicago Today* (1935), it states, "Commerce alone cannot build a great city, there must also be opportunity for the fullest expression of a happy, healthful life." In fact, it boasts that Chicago was one of the healthiest large cities in the world. "Good air, pure water . . . and modern sanitation make this the most desirable of all large metropolitan areas as a place to live." (Right, courtesy of Carol M. Highsmith Archives, LC, P&P DIV.)

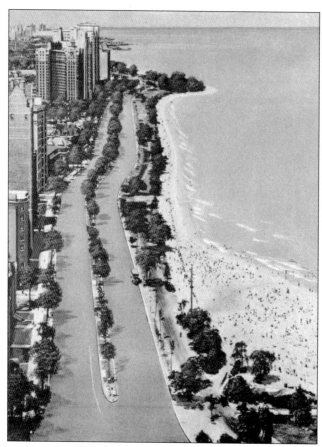

Lake Michigan provided an abundance of cool, clean water. Beaches were used for swimming, sunbathing, fishing, boating, and general relaxation. Shown here are two views of a north side beach with the Gold Coast in the background. Harbors were also part of the shore's recreation. Belmont Harbor in Lincoln Park sheltered motorboats and yachts, which could be seen sailing far out in Lake Michigan (which is about 580 feet above sea level). Other yacht harbors were located at Jackson and Grant Parks. By 1935, Chicago had spent $230 million to keep the waters pure for drinking, bathing, boating, and sewage disposal. Water from the lake was pumped through the city's new water tunnel in 1935. More than a billion gallons of water per day were pumped at 12 major pumping stations. (Below, photograph by John Vachon, courtesy of LC.)

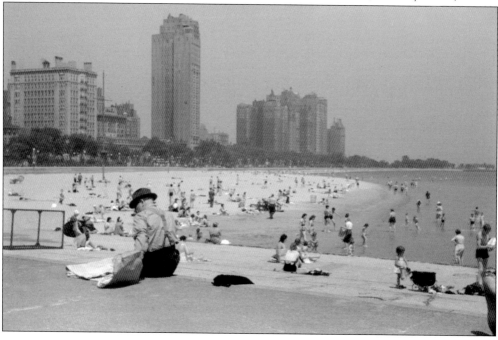

If one could not get to the lake, as was the case in daily life in the neighborhoods, one could still access its cool waters. Shown here are children on the near west side, enjoying the sculptures and fountains at the Jane Addams Housing Project, built in 1938 by FDR's WPA program. (Photograph by Peter Sekaer, courtesy of LC.)

Children in a South Side neighborhood opened the fire hydrants for a refreshing quench from the hot Chicago summer. It was an easy task, taking only a monkey wrench to turn on the hydrant. This could not last long, since it created low water pressure in the buildings. Before long, some concerned parent would call the city to come and close the hydrant, but until then, it was a joyful experience. (Photograph by John Vachon, courtesy of LC.)

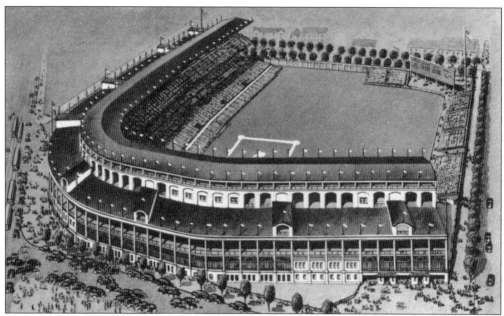

Wrigley Field, located at Addison and North Clark Streets—home of the Cubs—had a seating capacity of 45,000. In baseball folklore, it is where Yankees' hitter Babe Ruth pointed to the bleachers during game three of the 1932 World Series against the Cubs and then blasted a homer off the pitch of Charlie Root into that very spot. The series ended in the Yankees' favor, but the controversy of "the Babe" (did he really "call his shot" or was he only pointing back at Root?) and the harsh rivalry between the two teams created a great moment in the history of Wrigley Field. It was also the home of the Chicago Bears between 1921 and 1970. There, the Bears won the NFL Championship in 1932, 1933, and 1934. (Below, courtesy of John Chuckman.)

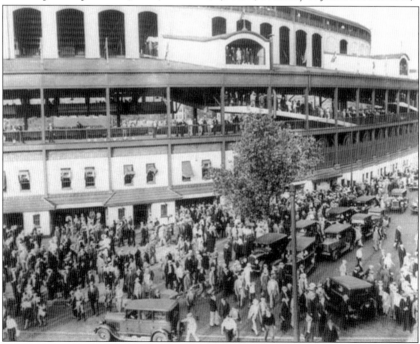

Shown here is Red Grange (holding the football), nicknamed "the galloping ghost" because he was so fast he seemed to appear from nowhere, and teammate Joe Zellar practicing at Wrigley Field. After an injury in 1925, Grange returned to play for the Bears from 1929 to 1934 and drew in large crowds as an outstanding halfback. He was later inducted into the College Football Hall of Fame (1951) and the Pro Football Hall of Fame (1963). (Photograph by Alan Fisher, courtesy of LC.)

Bronislau "Bronko" Nagurski played for the Bears alongside Red Grange. Nagurski was named All-Pro three times. He was a hard hitter who plowed through defenders. Once, during a Redskin's game, he bounced off the goal post, hitting a brick wall behind the end zone. According to Chris Brophy (of the website *Football Diner*), when Nagurski returned to the huddle, he said, "That last guy hit me awfully hard."

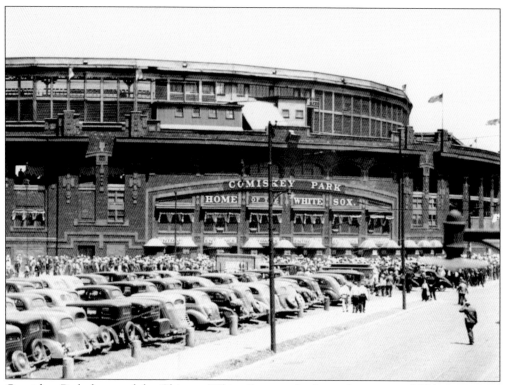

Comiskey Park, home of the Chicago White Sox, was built on the corner of 35th Street and Shields Avenue. In 1910, on Saint Patrick's Day, a bright green brick from Ireland was planted for good luck to commemorate the ground-breaking ceremony by Charles Comiskey. The South Side Park also served as the center for the Negro League Baseball, where, in 1937, the East-West All Star Game took place, bringing more than 50,000 fans. Even though the teams were segregated, the Negro League provided African Americans a professional place in the history of baseball. Besides baseball, on June 22, 1937, Comiskey Park sponsored the championship fight between Jim Braddock and Joe Louis, which packed the house. Visitors made up 75 percent of the fans; hotels had to be booked six weeks in advance. Louis knocked out Braddock in the eighth round to become the heavyweight champ.

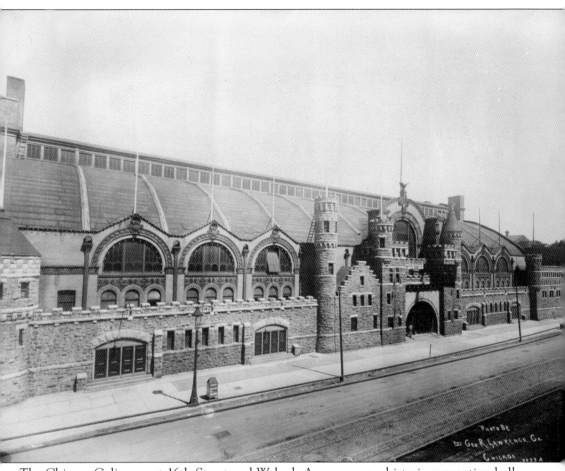

The Chicago Coliseum, at 16th Street and Wabash Avenue, was a historic convention hall where political conventions were held until 1933. The facade was built with material taken from the Libby Prison of Civil War fame. It also was where roller derby got its start during the Great Depression. It began with long-distance skating marathons, organized by Leo Seltzer in 1935, in which couples tried to skate for 3,000 miles. The idea then developed into a contact sport in which two teams of five, both male and female, skating on a banked track, competed against each other. Hazel Roop began competing in 1936. In an interview with Davis Block, Roop said she learned the sport because it was the only one in which a women could become a professional athlete and get paid. At the age of 97, Roop was inducted into the Roller Derby Hall of Fame on November 13, 2010. (Photograph by Geo R. Lawrence Co., courtesy of LC.)

The Chicago Stadium, located at 1800 West Madison Street, was especially designed for expositions, conventions, concerts, circuses, and sports. The National Convention of 1932, where Franklin Delano Roosevelt was nominated for president of the United States, was held there. In his acceptance speech, FDR assured the American people that "out of every crisis, every tribulation, every disaster, mankind rises with some share of greater knowledge, of higher decency, of purer purpose."

The Chicago Stadium was also the home of the Chicago Black Hawks. Pictured here are (from left to right) right-winger Mush March, center Elwin "Doc" Romnes, and center Paul Thompson. March scored the winning goal in the second overtime period against Detroit during the playoffs. The Hawks won the 1934 Stanley Cup for the first time in their franchise.

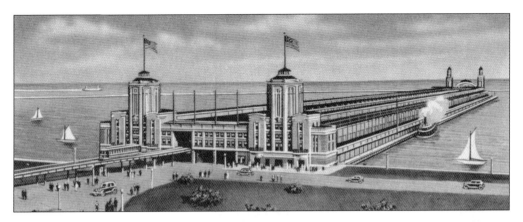

Navy Pier is located at the Chicago River as it connects to Lake Michigan. Originally at a cost of $4 million, the pier served as a dock for lake steamers and was an essential location for importing goods, especially coal. From the pier, one can see the Chicago Harbor Light House that, according to the National Park Service, played an important role in the development of the Port of Chicago by safely guiding ships in and out of the harbor and to the pier. In 1935, five lake steamship lines still operated both passenger and freight services between Chicago and other Great Lake cities. During the summer, the lines connected passengers to summer resorts like Mackinac Island. These activities declined during the Depression, but as a civic and recreational center, Navy Pier flourished; various New Deal agencies were housed there. (Below, courtesy of PD-USGOV-DHS-CG.)

SEE CHICAGO'S WONDERS

The
BROOKFIELD
ZOO

GO *by* "L"

Hear the lions roar; flip peanuts to the bears;

The Chicago Zoological Park, in Brookfield, Illinois (a suburb of Chicago), also known as the Brookfield Zoo, had ample parking for automobiles; also, it was easily accessible by taking the "L." Thursdays, Saturdays, Sundays, and holidays were free days; however, children under the age of 15 were always admitted free of charge. The official opening date was June 30, 1934. It was promoted as a "barless zoo" because one could view the animals in natural enclosures rather than in cages. Besides the polar bears, popular exhibits included Ziggy the male elephant and Su-Lin, the first giant panda to be seen outside of China. Su-Lin arrived in 1937, but he died of pneumonia the next year. (Left, photograph by John Vachon, courtesy of LC; below, photograph by Kathleen Schonauer.)

Edging Chicago is the Forest Preserve District of Cook County. In 1934, more than 18 million people enjoyed the trails, picnic grounds, woods, and golf courses. The preserves were open year round, from summer through winter, always providing unique points of interest and activities. Fresh winter snow on the trees furnished a contrast to the snow piles in the city. (Photograph by Kathleen Schonauer.)

Driving was the easiest way to access the forest preserves from the city. Here are sisters Bess (left) and Amy Haas posing on a 1933 sedan during a summer picnic. Bess saved enough money to buy the car by pumping gas at a local station, but she still needed a license. She said, "I sent in my fifty cents and my license came in the mail." Afterwards, she learned how to drive.

Seen above from left to right are John Vachon, Arthur Rothstein, Russell Lee and Roy Stryker of the Farm Security Administration. Stryker launched the documentary photography movement to create an official visual record of the lives of people during the Depression. Stryker chose the photographers and assigned them their territories. Vachon, Rothstein, and Lee came to Chicago, along with Edwin Rosskam (below), Dorothea Lange, and Jack Delano (not pictured) to document the American way of life. Vachon and Delano mostly photographed people and places encountered on the street, Lee and Rosskam incorporated economic and cultural activities, and Rothstein usually sought out domestic activities. The photographs they created, as seen in this book, are remarkable images that captured the emotions as well as the plight of each subject. Aesthetically resplendent, the photographs are works of art as well as of history. Because of this collection of work, which is now housed at the Library of Congress, people can observe (and not only read about) the challenges, joys, and milestones of Chicagoans during the Great Depression. (Above, photograph by Beaumont Newhall; both, courtesy of LC.)

Bibliography

Century of Progress International Exposition. *Official Guide Book of the World's Fair of 1934*. Chicago: The Cuneo Press, Inc., 1934.

Chicago Today. Chicago: The Chicago Association of Commerce, 1935.

Ferris, Jean. *America's Musical Landscape*. (Fifth Edition). New York: McGraw Hill, 2006.

Ganz, Cheryl R. *The 1933 Chicago World's Fair, A Century of Progress*. Champaign: University of Illinois Press, 2008.

Millar, Ronald, ed. *World's Fair Weekly*. Vol.1, No. 6. Chicago: Century of Progress International Exposition Administration, 1933.

Natanson, Nicholas. *The Black Image in the New Deal: The Politics of FSA Photography*. Knoxville: University of Tennessee Press, 1992.

Paddor, Scott, producer. *St. Valentine's Day Massacre*. United States: History Channel, 2013.

PPI Entertainment Group. *The Gangster Chronicles, Part I and II*. United States: Peter Pan Industries, Inc., 1997.

presidency.ucsb.edu

www.archive.org

www.chicagodefender.com

www.encyclopedia.chicagohistory.org

www.fbi.org

www.missamerica1933.com

www.wttw.com

DISCOVER THOUSANDS OF LOCAL HISTORY BOOKS FEATURING MILLIONS OF VINTAGE IMAGES

Arcadia Publishing, the leading local history publisher in the United States, is committed to making history accessible and meaningful through publishing books that celebrate and preserve the heritage of America's people and places.

Find more books like this at
www.arcadiapublishing.com

Search for your hometown history, your old stomping grounds, and even your favorite sports team.

Consistent with our mission to preserve history on a local level, this book was printed in South Carolina on American-made paper and manufactured entirely in the United States. Products carrying the accredited Forest Stewardship Council (FSC) label are printed on 100 percent FSC-certified paper.

MADE IN THE